TypoMag

Mark. Double Spread, number 21, September 2009.

What is TypoMag?

Laura Meseguer
www.laurameseguer.com

Editorial design is in luck. There may never have been such a proliferation of magazines as during the last five years, the good news is that this is not simply a local phenomenon, but something that is growing and not only in this country. Thus, it is logical that publications will periodically appear about the magazines and their designs. While there are many kinds of magazines catering for all kinds of audiences, TypoMag wanted to focus on those which we consider to be creating their own identity, largely in the use of typography and hence their value.

Every magazine is searching for a way to be different and attract a particular audience, and that is presented in a specific way through a format, photographs, a type of paper, a journalistic style, all parts of a whole, linked by typography. So we could say that typography has become one of the main differentiating elements, not only in design but also in topics.

In **TypoMag** we analyse the use from different aspects. We have created a series of labels or "tags" which allow us to guide the reader while permitting the recognition of certain attributes of the magazine. These labels are:

BY HAND: Letters, words and texts which are illustrations or have been drawn or constructed in a manual way, as in the case of *Love* (page 88).

CLASSIC: Magazines that use classic fonts, understanding them to be those typefaces that were designed over forty years ago, like *Monocle* (page 100).

IDENTITY: Magazines, in which typography defines their identity, either because they only use one family or because of the way they use it, like *Back Cover* (page 16).

CUSTOM TYPE: Magazines that use one or various made to measure fonts. We can say that, nowadays, newspapers and magazines are an important source of employment for type designers. This book provides examples of typefaces or titles specially designed for magazines, like the fonts designed for *Suite* (page 166), the design of *Sang Bleu* (page 152) for the magazine of the same name or the development of different typefaces for *Paper Planes* (page 138).

LOGO: Magazines that vary the logo design in each issue; giving them a new meaning or relating them with the content at that time, such as *OASE* (page 132).

HEADLINE DESIGN: Referring to those magazines that use headings for sections or made to measure articles like *Futu* (page 52).

DESIGNER: those magazines edited and produced by designers, like *ink* (page 60).

The New York Times Magazine.
Cover, September 2007.

The role of typography

Typography plays a major role, which is that of communicating and it does it by titles, paragraphs, columns and is based on how these are integrated with the other elements of the magazine, thus defining the style (sober and functional, fun and flashy, etc.). Typeface is used on three basic levels: texts (arranged in columns, paragraphs around images or on pages), headlines (in words or phrases) or in small sections (such as subtitles or captions) or even others that are more discreet (page number, section titles).

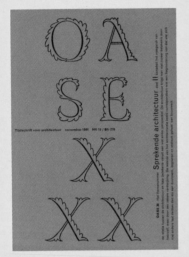

Oase. Cover, number 30.

The use of typography: Intelligibility and readability

Intelligibility is not consistent with readability as a text may be intelligible (can be read) but not readable; i.e. a text is readable if it is perceived by the reader as enjoyable and interesting, something which depends on factors such as the difficulty of comprehension, diversity of content, length of sentences, word choice. From this point of view, we show some magazines that are designed to be skimmed; their pages are full of combinations of typography, illustrated titles or letters interacting with images like *Love* (page 88) or *Untitled* (page 170). Other magazines are designed to be read in depth, and combine impeccably laid out texts (column widths, spacing, and choice of typography) with a more or less striking heading, like *The New York Times Magazine* (page 112) or *Wired UK* (page 174). There are also magazines designed to be understood as an experiment or an exercise in style, where the text block and blanks on the page play a critical role, like *Newwork Magazine* (page 120) or *Lieschen* (page 78). They are normally magazines where the editor is also the designer. Mastering the use of typography in magazine design is not easy because you have to have knowledge and skill in all these levels of communication. We think that all the magazines selected here are excellent in that regard.

Back Cover
Cover, Summer 2009.

We have prepared a section of typography blogs and magazines for those who work with them, who are beginning or simply want to expand their knowledge level. ("Annex" page 185).

Suite. Double Spread, number 40.

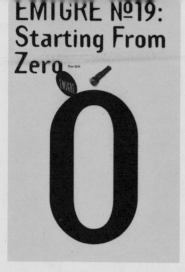

Emigre.
Cover, number 19.

Foreword

Luis Mendo
www.goodinc.nl

Writing an introduction for such a book as the one you are holding in your hands is a privilege. Not so much because the makers of it are good friends and deserve this and more, nor because I know they have been rigourous and just, but mainly because as far as I know there's no book like this. The study of type use in magazines is something not many people pay attention to.

No magazines without type

While magazines are mainly seen as colourful things with loads of pictures, they are actually the best living example of the marriage between image and text. Not one can exist without the other and although there have been experiments of doing text-only or image-only (*COLORS* comes to mind) magazines, I think they've become less exciting objects; they lose the depth the mix of pictures plus text offer. The twist a caption can offer to a picture is of great value and I'd dare to say that's exactly the magic that makes magazines so appealing.

While most of the art directors I know are better with pictures than with type, there are a few examples of them who prefer to work the type deeply and excel on it. Needless to say, there are just a few with the mastery to control both worlds, those are the real geniuses.

Among editors and publishers, typography is often the forgotten kid, so there you have more reasons to make this book.

Type are types

Often in my teachings I use the metaphor that magazines are old radio shows. You probably know those: a story being told on the radio, with many different characters coming in and out of rooms, expressing their personalities only through voice differences, accents, maybe on the way they pronounce the letter "R". Not one single image to illustrate it and all the information we get to know what happens and how people react are sounds: the different voices, the special effects, the changes of rythm, the dialogues.

This is exactly how type works. You have just words, combinations of letters that create ideas, being interpreted by the reader. But the type treatment helps us understand - before you read one word - what is important, what is not, if it is a story about politics or a light gossip article, is the editor against this? or does he hate it? All this is being told by type.

In other words, you could "read" a magazine of a language you totally don't know just by looking at the type treatment: the size, the chosen typeface, the color, is there an underline, a decoration? All those things are the sounds of a radio show, telling us who's the good guy, who's the bad guy and who's the girl in the story. Thank god for type.

The power of type

In an era where we are literally immersed in messages, the personality, size, font and the treatment of type can tell you much more than words alone can. That makes the art director behind a magazine such an influential figure with the power to say things, to make the reader read something or neglect it.

Not reading, not understanding and not feeling something for the story being told on the page is something an art director can't afford. He or she must impregnate that feeling in the layout and more importantly in the treatment of the type. This makes this book on itself quite a good read, as it shows us how great art directors succeed in doing this with their work.

Handpicked examples

When Laura and Floor told me they were doing a book on magazines typography, I was very afraid it was going to be one of those boring books that start by looking back on time and see how type has developed throughout the years, with many examples you already know, only arriving at the most modern stuff in the last pages. Luckily for us, that is so not the case in TypoMag.

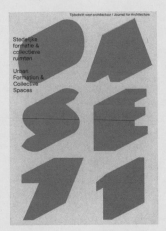

OASE. Cover, number 71.

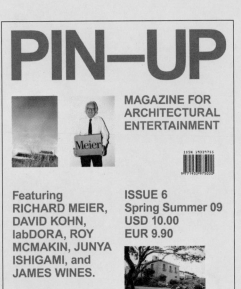

PIN—UP.
Cover, number 6.

Nico. Cover, number 1.

They have chosen great titles, some of which I didn't know until now. I am pretty sure their choice is based on guts as well as on brains. Laura is a very scientific person when it comes to typography and her deep knowledge of the matter is something I would very much like to steal one night while she's asleep. Strikingly accurate answers came when I asked her why not include this magazine or take that one out. Thanks again, Laura, for the lessons learned.

Analysis

Laura and Floor have analysed the magazine in the way you want to analyse them: which font they use, why, what are the minds behind the magazine thinking, those kind of things that –next to peeking at the places where the people work, something we unfortunately miss in this book– we all want to know and understand. Well done!

Tags

The authors have given the book tags for easy navigation. Being a nifty handy feature, I like the idea I can find some kind of treatment just by searching through the tags.

The most populated of these tags are curiously 'headline design' and 'custom type'. It was only a natural thing that both of them would be the most populated: well designed magazines nowadays need to stand out from the rest. The ads are visually better than ever before, asking for attention and exposing a colourful world to the reader. How to stand out from it? A very good way is by using a custom made typeface –which you won't easily find in the ads– and using it throughout the mag or maybe only in the headlines. This will add to the diferentiation but as well to personality building. Not an unimportant thing.

Type as image

Reviewing the chosen magazines in this book I cannot help but notice how many of them are a pretty good example of the idea that type, in fact, is image. And sure thing a very special image. When a magazine has its own personality through the used typefaces, this personality grows and manifestates itself pure and clear. Image being so important, type is the corporate identity of your magazine.

Nevertheless, when creating a new title, it is a normal thing to discuss long hours about the image policy. We spend loads of time and energy on getting the right image style and descriptions for that particular title so nobody has doubts as what the magazine stands for. Strangely, my experience is that type doesn't create so much debate and it's usually decided singlehanded by the art director. This is a very strange phenomenon, if you think about it. Type will define the magazine look and feel as much –sometimes much more– as image, so why is it so underrated? My humble conclusion is that publishers feel more confident when they talk about things they understand, and typography is something that escapes the reasoning of many. An Helvetica will say something to me that it's not what it means to you. This difference makes it a difficult item to discuss and debate. And that is probably the charm of it.

I am confident that a book like the one you are reading is a good starting point and an important argument on why type really matters and is one of the pilars of the magazine world.

Monocle. Index Page, number 28.

The future

Overviewing the book you can easily spot two different trends: one being the "classical" approach as in *Monocle*, *Nico* and *Suite* and the more "experimental" like *Love* and *Elephant*. Although it's difficult to speak of trends, it is true that we are seeing maybe more of the Classical approach at the moment, but I think designers are more conscious of trends than ever before and they come with a counterreaction whenever they feel like it's time for a change. I am very glad TypoMag is a nice compendium of very different titles so we can lean back and enjoy the whole spectrum.

Enjoy the ride.

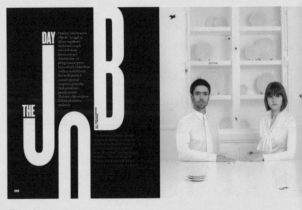

Futu. Double Spread, number 6.

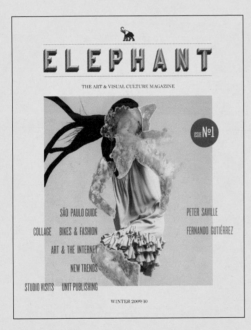

Elephant. Cover, number 1.

Emigre. Double Spread, number 60.

Magazines

Editor / Director: **Kieran Long**
City / Country: **London / United Kingdom**
Founded in: **1896**
Art Direction / Graphic Design: **Violetta Boxill** and **Cecilia Lindgren**
Dimensions: **230 x 280 mm**
Number of pages: **variable**
Language: **English**
Periodicity: **monthly**
Website: **www.arplus.com**

THE ARCHITECTURAL REVIEW

1347 MAY 2009 £9 / €17 / $25 WWW.ARPLUS.COM

Fuksas' church in earthquake-striken central Italy
Cultural centre in Dublin by O'Donnell + Tuomey
Alan Balfour on the Neues Museum in Berlin
VIEW/ Pritzker Prize-winner Peter Zumthor/
Gaza, Israel and urbanism / Kyoto of the Cities

CLASSIC

LOGO

TypoMag / *ar*

11

The *Architectural Review*, (*ar*), is a monthly magazine which presents a thoughtful, critical and at times provocative vision of contemporary global architecture.

Founded in 1896 this seminal publication features articles on the built environment, including landscape, building design, interior design and urbanism as well as theory around these subjects.

When redesigning the team asked themselves what they felt the *ar* should stand for. Although there was no single answer they knew the key was to have a clear direction on its editorial stance.

That stance ranges from the traditional interests, (context; the city; a broad definition of architecture as a social and cultural praxis; criticality), to a more current position, (cosmopolitanism, an interest in popular culture, excitement about a range of design disciplines). This sensibility defined the choices on everything from the typography of the magazine to the choices made about content.

Beautiful images, accessible text and engaging layout combine to give a comprehensive overview of the contemporary architectural landscape.

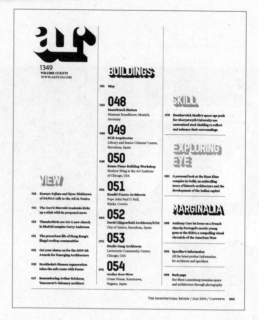

The Architectural Review. Contents page. Number 1349. July, 2009. Two fonts are used in varying degrees throughout the publication. The sans serif is *T-Star*, designed by Swiss type designer Mika Mischler. It has a sharp, technical and contemporary appearance, (it was released in 2008). It is also used as body copy in the Skill and ID sections. The serif is *Mercury*, designed by Hoefler & Frere-Jones as a high performance typeface for the newspaper industry. It was first released (after nine years of development) in 2007.

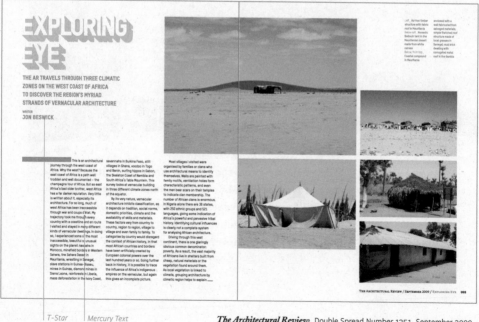

T-Star | Mercury Text

The Architectural Review. Double Spread Number 1351. September 2009.

The Architectural Review. Redesigned logo.
The new logo is a clear reference to the logo used intermittently by the *ar* in the 1960s, 1970s and 1980s. The re-design was a collaboration between *ar*'s art director Cecilia Lindgren, (www.cecilialindgren.com) and creative director Violetta Boxill from alexanderboxill (www.alexanderboxill.com)

The Architectural Review. Old logo, used by the *ar* in the 1960s, 1970s and 1980s.

In honor of the *Architectural Review*'s tremendous legacy the redesign journey started by looking back through its archive. Visually, its graphic heyday was under the art direction of William Slack so Boxill and Lindgren chose to re-draw/re-configure one of his original mastheads. Therefore embracing the past but introducing a new contemporary slant by rendering the letterforms as one merged unit, something that was impossible in Slack's day as he used metal type.

The new design incorporates two fonts, the serif *Mercury*, designed by Tobias Frere-Jones and the sans serif *T-Star*, designed by Mika Mischler, Gestalten. Each are used in varying hierarchies and intensities throughout the publication to add texture, clarity and variety to the publication.

Editorially the idea of gleaning from the *ar*'s rich past is echoed by introducing sections with names unearthed from issues of the same era.

The magazine is divided in to three main sections View, Buildings and Marginalia. These sections provide a flexible structure allowing for text heavy technical pages to image-led photo stories.

The magazine pushes the expectations of the reader but doesn't lose sight its loyal audience. Using stunning photography and insightful critique the new journal celebrates a wide range of architecture becoming not only an inspirational and essential guide but also a faithful friend.

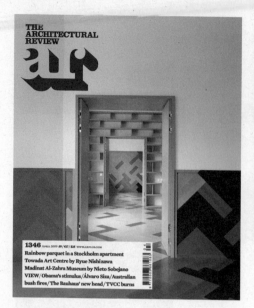

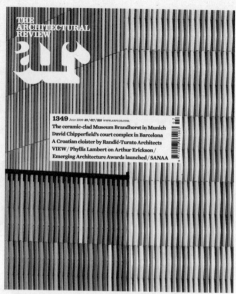

The Architectural Review. Cover. Number 1346. April, 2009.

The Architectural Review. Cover. Number 1349. July, 2009.

028 HOUSE N **SOU FUJIMOTO ARCHITECTS**

THE HOUSE IS A HYBRID; A SERIES OF BOXES IN BOXES THAT DEFINE DOMESTIC REALM, ENCLOSURE AND INTERIOR

The Architectural Review. Double Spread. Number 1346. April, 2009.

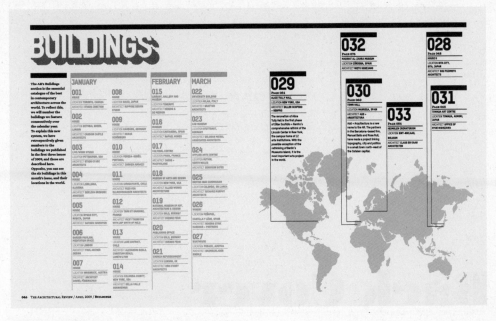

The Architectural Review. Double Spread. Number 1346. April, 2009.
The typefaces used are *T-Star*, designed by Mika Mischler (Gestalten), and *Mercury*, designed by Tobias Frere-Jones (Hoefler & Frere-Jones).
The choice of fonts is due to their clarity and versatility.

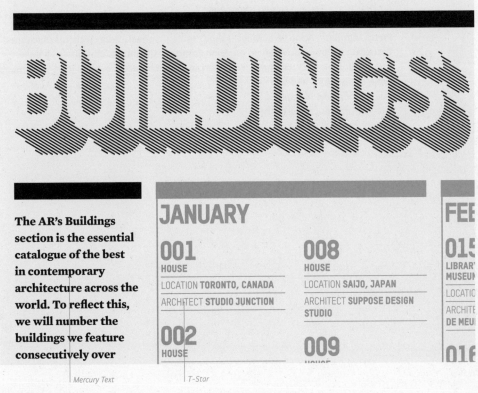

Mercury Text T-Star

The Architectural Review. Double Spread. Number 1346. April, 2009. Detail in actual size.

'If Back Cover *were to reincarnate,
it might be a radio show'*

Back Cover

Editor / Director: **Alexandre Dimos, Gaël Étienne** and **Véronique Marrier**
City / Country: **Paris / France**
Founded in: **2008**
Art Direction / Graphic Design: **deValence**
Authors: **Abake, Peter Bil'ak, Aurélien Froment, Richard Hollis, Annick Lantenois, Pierre Leguillon, Anne Lemonnier, John O'reilly, Raphaël Zarka, François Chastanet, Catherine de Smet, deValence, Aurélien Froment, Olivier Gadet, Christoph Keller, Étienne Robial, Jan Tschichold, Yann Serrandour, Robin Kinross** and **Jean-Yves Jouannais**
Dimensions: **195 x 280 mm**
Number of pages: **60 aprox.**
Languages: **French / English**
Periodicity: **twice a year**
Website: **www.editions-b42.com**

BACK COVER

DESIGN GRAPHIQUE, TYPOGRAPHIE, ETC.
GRAPHIC DESIGN, TYPOGRAPHY, ETC.
**François Chastanet | Dominique Darbois | Catherine de Smet | deValence |
Elektrosmog | Aurélien Froment | Olivier Gadet | Christoph Keller |
Władysław Pluta | Étienne Robial | Jan Tschichold |**

2

PRINTEMPS/ÉTÉ 2009
SPRING/SUMMER 2009

ON
SUIS
'HEUREUX
NOUS "WE
ESTER HAPPENED
ES » « LES TO BECOME
THE LIVRES VERY LOCAL
MBER FONT DESIGNERS"
USED LES AMIS »
RLY
"

« EN 32,
J'AI UN
MOINEAU »
Aurélien Froment
et Benoit Rosemont p.14

Elektrosmog p.23

Christoph Keller p.45 "I NEVER
READ THIS
KIND OF
« JE SUIS BLURB"
INTRIGUE PAR
LES REMONTÉES
DE COLLE »
Olivier Gadet p.30

Étienne Robial p.11

.35

NE
ME

Y A "MY MOST VIVID
ES MEMORY: NORIKO"
OQUILLES »
Catherine de Smet p.24

La photographie illustrée. Les « Enfants du monde » de Dominique Darbois

CATHERINE DE SMET

Mon souvenir le plus vif : le bain de Noriko, la petite Japonaise, dans une gigantesque cuve en bois. Seule la tête de la fillette dépasse. Elle regarde en direction de sa grand-mère accroupie, qui souffle sur les braises pour entretenir la chaleur de l'eau. La partie inférieure de la photographie, en noir et blanc, est détourée et complétée par un aplat vert qui remplace en quelque sorte le sol, visible dans la prise de vue initiale [...]

[body text partially illegible]

Dominique Darbois, Noriko, la petite Japonaise, Paris, Fernand Nathan, 1951, 21,5 × 25,5 cm. Auteur de la maquette non mentionné.

Dada Grotesk

Back Cover. Double Spreads. Spring / Summer 2009.

Le chiffre à la lettre. Entretien avec Benoît Rosemont, illusionniste

AURÉLIEN FROMENT

Aurélien Froment Pour démarrer, j'aimerais que vous décriviez le déroulement d'un spectacle de mémoire prodigieuse.

Benoît Rosemont Le spectacle que je présente est basé sur le thème de l'école... À l'école, j'étais plutôt mauvais élève et préférais jouer aux cartes. Je présente donc une première expérience de mémoire à partir de cartes à jouer. Je mémorise dans un ordre x ou y. À l'école, on apprend aussi les nombres, alors je demande au public un nombre de vingt chiffres que je note sur un « paper board ».

[interview body text largely illegible]

Back Cover. Double Spread. Spring / Summer 2009.

Sommaire

The name *Back Cover* helps the designers to figure out what is not obvious at first sight; it suggests everything that is behind it: the process, history, the visual art experiences and more specifically, graphic design and typography.

This publication focuses on the analysis and discussion of graphic design, the different typefaces and visual art. The magazine is a meeting point which gave the designers the perfect means of exchanging ideas, ideas which, despite the passage of time, they can always rescue from some of the numbers that they have stacked in a corner.

Dada Grotesk is the typeface of the magazine, it was created in 2006 by de Valence and distributed by Optimo since 2008. The designers are also the editors and so they are responsible for the content and design of *Back Cover*. Names like Jop van Bennekom, Stuart Bailey, Peter Bil'ak, Abake,

Back Cover. Interior page. Spring / Summer 2009.

Traducteurs invisibles. Entretien ave Elektrosmog

Valentin Hindermann & Marco Walser

DEVALENCE

Depuis 10 ans, le studio zurichois Elel
un design graphique sensible, intellige
Valentin Hindermann et Marco Walser
de clients principalement suisses, préf
le sens à l'effet de style, et se position
volontairement en retrait. Cette discré
un statut quasi confidentiel hors de leu
Contexte, commande, méthode: ils dév
une partie de leur univers.

Back Cover. Spring / Summer 2009.
Detail of the use *Dada Grotesk* typeface in actual size.

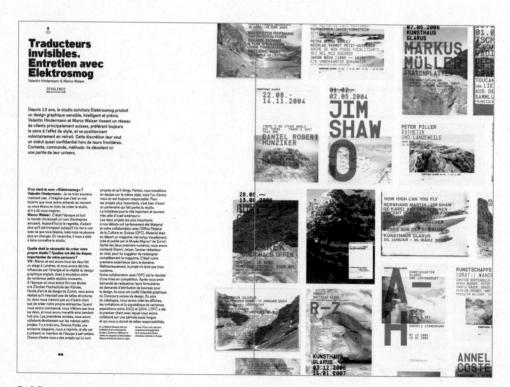

Back Cover. Spring / Summer 2009. Double Spread "Invisible translators". Interview with Elektrosmog by deValence.

Dada Grotesk
Une famille de caractères du Light au *Heavy italic*.

Dada Lumière.
Dada Livre.
Dada Support.
Dada Gras.
Dada Lourd.

Dada Grotesk
The whole family from Light to *Heavy italic*.

Dada Grotesk is the typeface of the magazine *par excellence*, it was created in 2006 by deValence and distributed by Optimo since 2008.

The typeface *Dada Grotesk* was designed by deValence (Alexandre Dimos & Gaël Étienne), a Paris-based graphic design studio active since 2001 in the field of printed matters, mostly artists and exhibitions catalogues. *Dada Grotesk* was initially designed in 2005 for the book and the signage of the DADA exhibition at the Centre Pompidou, Paris. Based on a typeface found in the 1918 issues 3 and 4/5 of *Dada* magazine, this text-and-display typeface, with quiet but tough shapes, reminisces simultaneously the esthetic of early *American Gothics* and German *Grotesks*. After two years of development, the Dada Grotesk family was finally complete with its italics and a new heavy cut (Dada *Lourd*).

Will Older are the best examples of interest in those magazines created entirely by designers.

With a clear simple design, the objective is the design in itself, the visual information is obvious. With no other intention than to be what they are, their "less is more" motto is more feasible for the magazine to be possible from an economic point of view. *Dada Grotesk* allows them to not only show shapes, but also show how a typeface may become a real part of the magazine design itself. Its unique appearance, the idea that "the less you see the better the read" is its best attraction. With every number there is a search for a new use for the typeface. The objective is the surprise, the game; it is like a pet for its designers.

With a cover where a thousand words are worth more than an image, *Back Cover* is searching for something else. It is looking for something different, a hallmark that distinguishes it from other graphic design publications, that is why it is so hard for the designers to find photographs on the covers or headers. The change in the latter is due to a name change. The magazine published three numbers with the name of *Maria Louise*. This transformation is the result of teamwork, of the assignment of changing roles which seek the novelty of self-questioning and finding their own answers. The magazine is a meeting point where reflection, inspiration and analysis go hand in hand.

'A person named Carl'

Carl's Cars

Editor in chief: **Karl Eirik Haug**
City / Country: **Oslo / Norway**
Founded in: **2001**
Creative Director: **Stéphanie Dumont**
Dimensions: **230 x 280 mm**
Number of pages: **variable**
Language: **English**
Periodicity: **quarterly**
Website: **www.carls-cars.com/flash.html**

CLASSIC

carl*s cars

a magazine about people

HEADLINE
DESIGN

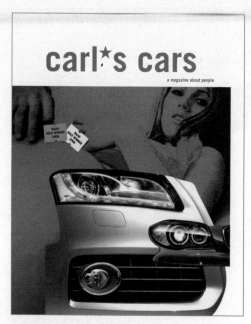

Carl's Cars. Cover. Number 25. Spring 2009.

If there is a magazine which includes such varied concepts as opinion, style, humour and trends with a personal style, you may be holding *Carl's Cars* in your hands.

Carl's Cars is a magazine about people and that was the main reason that the decision was taken to use a proper name, Carl, to underline the personal style of the publication

Carl's Cars was the first magazine to dare merge car culture with such varied subjects as music, fashion, cinema and design. Perhaps that is why *Carl's Cars* is a publication about people's creativity; in short, they are interested in the crazy things we say, the things we do and the cars we drive. Each and everyone of the characters is a friend of the magazine. The design shows a highly personal point of view and a socio-cultural presentation done by known writers and photographers of prestige.

Designers are striving to use their creativity to combine different skills and make the best of them. Even though the magazine contents mainly depend on the designers, they leave the choice of the factors that make *Carl's Cars* unique up to the readers' opinion. Aspects like

the paper or the size of the publication do not seem to have much relevance in the creators' opinion, but the font is especially destined to fit in with the style and personality of the magazine content.

What is their philosophy? We could say that a fundamental aspect and perhaps one of the most important is that the fonts fit their communication objectives, fulfil their role and what they wish to convey.

Despite the different changes in typography throughout the history of the magazine, none has been a clear or marked revolution. If we had to compare these changes with something that was easy to understand we could compare it with the changes that a person experiences throughout his life. Among the wide assortment of types, using some of their own creations, certainly gives a personal characteristic.

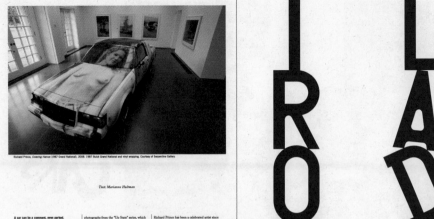

Richard Prince, Covering Hanna (1987 Grand National), 2008. 1987 Buick Grand National and vinyl wrapping. Courtesy of Serpentine Gallery.

Text: Marianne Hultman

A car can be a comment, even parked.

Last summer, the Serpentine Gallery in London presented an exhibition of Richard Prince' works entitled "Continuation".

"Covering Hannah" (1987 Grand National) from 2008 is a Buick Grand National wrapped in adhesive vinyl, the same material used for adverts on buses and trains. The wrapped image is part of the "Girlfriend" series, comprising re-photographed biker magazine photos of women, often the girlfriends of bikers, on car bonnets and bikes. On the walls, you'll find

photographs from the "Up State" series, which documents the area in upstate New York were Mr Prince lives and works.

Mr Prince is a collector of art, furniture, memorabilia and books, all housed in a variety of buildings surrounding his home and studio. The exhibition aimed to create a dialogue between Richard Prince the artist, and Richard Prince the collector.

It was the artist's first major exhibition in the UK and featured works covering Mr Prince's 30-year career, personally selected by the artist himself.

Richard Prince has been a celebrated artist since the 1980s. In works such as the Cowboys, Jokes and Hoods series, he appropriates images from magazines, popular culture and pulp fiction to create new photographs, sculptures and paintings that respond to assumptions about American identity and consumerism. They also take a critical look at the issues of authorship and the value of art.

The exhibition was arranged by Mr Prince himself, in collaboration with gallery director Julia Peyton-Jones, co-director Hans Ulrich Obrist, and curator Kathryn Rattee. ❖

108

Carl's Cars. Double Spread. Number 25. Spring 2009.
Functional typefaces are used (*Trade Gothic* and *Adobe Caslon*) for the text, and typefaces reminiscent of car license plates are used for headlines. According to the designers, these have been chosen to reflect the magazine tone and content. If you want a philosophy behind the use of a "made to measure" typography, it would be the search for a better communication.

Trade Gothic *Adobe Caslon*

A car can be a comment, even parked.

Last summer, the Serpentine Gallery in London presented an exhibition of Richard Prince' works entitled "Continuation".

"Covering Hannah" (1987 Grand National) from 2008 is a Buick Grand National wrapped in adhesive vinyl, the same material used for adverts on buses and trains. The wrapped image is part of the "Girlfriend" series, comprising re-photographed biker magazine photos of women, often the girlfriends of bikers, on car bonnets and bikes. On the walls, you'll find

photographs from the "Up State" series, whi documents the area in upstate New York we Mr Prince lives and works.

Mr Prince is a collector of art, furniture, mer rabilia and books, all housed in a variety of buildings surrounding his home and studio. exhibition aimed to create a dialogue betwee Richard Prince the artist, and Richard Princ the collector.

It was the artist's first major exhibition in the and featured works covering Mr Prince's 30-career, personally selected by the artist himse

108

Carl's Cars. Double Spread. Number 25. Spring 2009. Detail of the use of *Trade Gothic* and *Adobe Caslon* in actual size.

Carl's Cars. Double Spread. Number 12. Summer 2005.

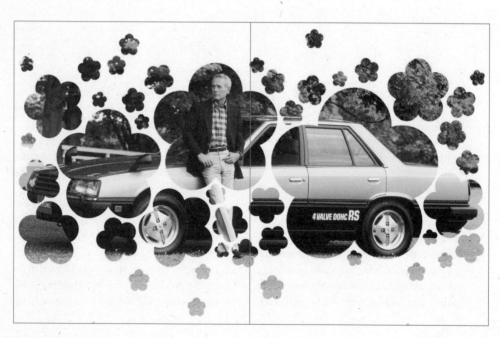

Carl's Cars. Double Spread. Number 6. Fall 2003.

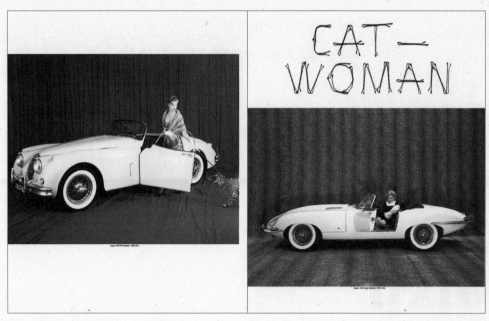

Carl's Cars. Double Spread. Number 15. Spring 2006.

Inspired by magazines like *Vogue, Nora, Esquire* and *Playboy*, the artistic direction has been renewed in an undeniably elegant way.

The independent character of the magazine is a crucial point to be taken into consideration by the director. They try hard to avoid economic ties that restrict their freedom. But they admit that finding a serious investor would help them go further in the department responsible for the organisational aspect of the magazine. Only with this independent character are they able to satisfy male and female public alike, readers interested in art and those interested in popular culture; a public that is intelligent enough to read a newspaper after having read *Carl's Cars*.

The magazine's secret is simple. It is nothing more than having converted a real life project into something deeply personal. The daily motivation is the knowledge that "there is a large sector of readers who are loyal to the publication and who really appreciate what we are trying to do."

"We are interested in people and cars, design and art. We present a prominent personality from the world of music or art, an employee from the Mini factory or a parking valet with identical respect. They all form part of this project about life that is *Carl's Cars*."

"mutant creation media"
"A Culture & Postdesign magazine"

Editor / Director: **Alejandro Benavent**
City / Country: **Valencia / Spain**
Founded in: **2000**
Art Direction / Graphic Design: **Alejandro Benavent**
Dimensions: **290 x 400 mm**
Number of pages: **variable between 48 and 56 pages**
Languages: **Spanish / English**
Periodicity: **quarterly**
Website: **www.dximagazine.com**

Cultura & Post-diseño
Número 34 / Año IX
VERANO / SUMMER
Junio_Septiembre 2009
Publicación Gratuita

34

d[x]i

CLASSIC

CUSTOM TYPE

HEADLINE DESIGN

DESIGNER

TypoMag / *d[x]i*

d(x)i comes from Valencia, Spain. In each issue this quarterly magazine offers a theme, around which more than 30 artists from different countries publish their creations. This variety of content used in a transversal way gives us a magazine with a multiple, contradictory and sometimes absurd result.

Alejandro Benavent, its director/editor, defines it as a "mutant creation media," "A Culture & Post design magazine." In this media we find the work of designers, photographers, architects, interior designers, illustrators, printers, sculptors, etc., some of who habitually work with the publication.

The multiple bonded activities convert the magazine into an organ that helps us understand and generate design. A magazine may become all or nothing and this depends on the editor and his followers. In the case of d(x)i magazine, this has a pivotal role as a dynamic entity in the "design culture."

If we go back to the origin of the magazine d(x)i nation was created in 2000 as a space for meditation and for experimenting with design. Taking this starting point, the magazine has acted as a point where views, opinions and ways of understanding and generating design come together. Despite its great critical spirit, it tries to offer different perspectives in order to provide the reader with a space for meditation where tolerance and respect for differences are considered to be essential conditions and needs for coexistence and understanding of society, which currently seems to be lacking in values and ideology.

In a time of changes, as multidisciplinary and mixed, so confused and uncertain, new definitions and territories seem to be cemented for design, and in this direction d(x) i has wanted to develop a social level of activism.

This has earned the magazine various awards like ADCV-ORO (2009), the LAUS trophy (2007), and the FAD medal for cultural merit (2004) among others.

As for the design of the magazine, the typography, layout and images are its three essential components. The designer has the leading role in the narrative construction of the magazine, but on the other hand, graphics, typography and imagery are essential factors in each issue.

Creativity and chance are two indispensable elements at the time of thinking outside of the box and d(x)i know how to do that. A clear example of this aspect is the act of appearing as a newspaper with a variable format, according to the subject at hand. With 25,000 units per issue, great care is taken in editing, design and contents in a mass media, with a free distribution.

This versatility in format takes on different roles and formats, that go from the most reduced as in (#11), to extra large, as in (#27). The letterpress selection in d(x)i continually evolves and changes, using a multitude of fonts from all families. Choice is conditioned by different criteria: subjects, aesthetics, historical, creative, experimental or functional.

Considering that each typeface is a very complex creative exercise, d(x)i leverages the expressiveness of each type to build the graphic narrative that the magazine requires in each case. Despite many changes, determined parts of the magazine have retained styles and types for years. There are classic spaces that work very well with the passing of time and on the other hand, there are other sections which need continuous changes. These changes are the result of d(x)i's taste for proposing creative exercises which present experimental alphabets and typography, conceptually supporting the theme of each issue.

d(x)i offers a publication which competes aggressively to attract attention and find a place in the sea of information that we are used to. Offering us a rigid yet, at the same time, simple structure, the leading role of the publication depends, without a doubt, on an image without text. The front page becomes a window which exploits its visibility to a maximum, the logo may vary in position and along with its free distribution and larger format, make it stand out and be clearly recognised from the others.

d[x]i.
Double Spread.
Issue 31.
September 2008.

d[x]i.
Double Spread.
Issue 32.
December 2008.
In this occasion the
issue was devoted
to terror.

d[x]i.
Double Spread.
Issue 30.
June 2008.
In this occasion the
magazine was devoted
to social issues.

Elephant

Editor / Director: **Marc Valli (Magma)**
City / Country: **London / United Kingdom**
Founded in: **2009**
Art Direction / Graphic Design: **Matt Willey (Studio 8)**
Photography: **Giles Revell** and **Julian Anderson**
Dimensions: **220 x 280mm**
Number of pages: **204**
Language: **English**
Periodicity: **quarterly**
Website: **www.elephantmag.com**

ELEPHANT

THE ART & VISUAL CULTURE MAGAZINE

ISSUE №1

SÃO PAULO GUIDE

COLLAGE BIKES & FASHION

ART & THE INTERNET

NEW TRENDS

STUDIO VISITS UNIT PUBLISHING

PETER SAVILLE

FERNANDO GUTIÉRREZ

WINTER 2009/10

CUSTOM TYPE

HEADLINE DESIGN

DESIGNER

TypoMag / *Elephant*

U N I V
E R S A
■ E V
L E T
E R Y T
H I N G

54

55

Elephant. Double Spread. Number 1. Winter 2009-2010.The design of the titles with *Knockout* is outstanding always in different ways, with variations of sizes and composition.

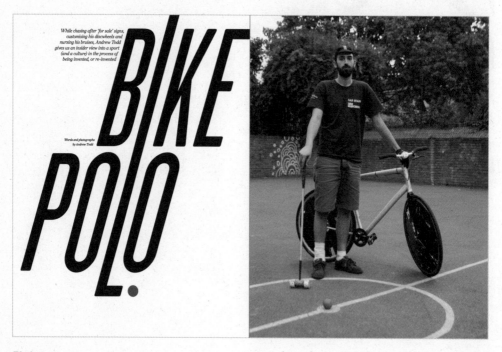

While chasing after 'for sale' signs, customising his discwheels and nursing his bruises, Andrew Todd gives us an insider view into a sport (and a culture) in the process of being invented, or re-invented

BIKE POLO.

Words and photographs by Andrew Todd

Elephant. Double Spread. Number 1. Winter 2009-2010.

Elephant comes to us from London. Founded in 1984, Marc Valli, editor and director, defines the magazine as the "new art and culture magazine." With more than 200 pages of visual content, his main objective is to create a deeper and more extensive projection than any other visual art magazine. With the wish to go even further, *Elephant* is a tireless seeker of new creative tendencies, artistic movements and innovative techniques.

During the last years there has been a creative revolution against the traditions or normal rules, taking the initiative and opting for a new line and a new adventure. *Elephant* has it sights on this kind of people and projects that opt for changes. How does one begin a new adventure of these dimensions? How can the personal interests of a publication change by the design of a highly visited website? How to change an obsession into a global tendency? By visiting new art and design studios, sitting down and talking, closely following graffiti artists, getting into trials and interrupting photo sessions, riding a bicycle and having fun with the latest computer games, *Elephant* is always there.

What is the reason for the change? The answer is, that something has happened in the art world. On the one hand, we have the world of art in its purest form, on the other, what has been called applied art or commercial art. While the most interesting and exciting was happening halfway between these two trends:

in that place where photographers, architects, graphic designers and fashion designers of all kinds have moved away from their initial creations and have begun to think like artists, at a point where artists have decided to stroll around museums and art gallery atmospheres and have absorbed the new trends and begun to think like real artists. In this "other way" creators have lost their fear of becoming committed to new technologies, creating "graphic" novels as complex as a traditional novel and novels as graphic as comics. In this "other option" we must not forget the illustration, graffiti, art and cinema.

Some ask themselves is this art or commercial art? *Elephant* says: "Who cares?". In this huge vital visual space where the magazine finds its place, with its vibrant culture and endless change of scene, there is *Elephant*.

Within this creativity framework, *Elephant* defines itself as a sincere, direct, multi-disciplinary magazine, seeking its hallmark in an earlier era than the fact that the world of arts and the creative industries took over the artistic field and the artists concern themselves more about the economic values of their works than the impact of their ideas.

Knockout and *Chronicle* by Hoefler & Frere-Jones are two of the fonts used in the magazine. *Népstadion,* used as a "guest" font, was designed by two recent graduates from the School of Art and Design in Bath.

Elephant. Double Spread. Number 1. Winter 2009-2010.The typefaces in use are *Knockout* and *Chronicle* (both from Hoefler&Frere-Jones).
A huge font in contrast with the small one, and the grids look very good together.

Elephant. Double Spreads. Number 1.
Winter 2009-2010.

Népstadion

Elephant. Double Spread. Number 1.
Winter 2009-2010. The "guest" typeface
Népstadion was designed by Benjamin
Hayward and Tim George, recent graduates
of Bath School of Art and Design. This
typeface was drawn from photographs of
the original 1950s signage found at the
Népstadion stadium (People's Stadium)
in Budapest, Hungary.

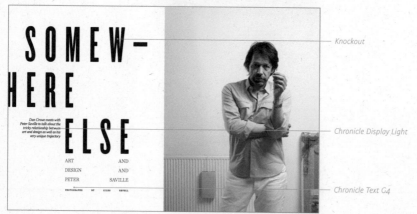

Knockout

Chronicle Display Light

Chronicle Text G4

36

Elephant. Double Spreads. Number 1. Winter 2009-2010.

EMIKE PERRY

LET THE IMAGES DO THE TALKING

Marc Valli interviews multi-talented artist (and 'doer') Mike Perry.

PORTRAIT BY ANNA WOLF

Brooklyn-based artist Mike Perry is just one of those people. He seems to be able to do so much work and cover so much ground that, in comparison, one cannot help asking oneself questions about one's own inactivity. It's like being in a vehicle going at moderate speed, and then being overtaken by a very fast one, and thinking, 'Have I stopped? Why am I not moving?'

Painter, illustrator, graphic artist, type-designer, art director, author, curator... Mike Perry won't be squeezed into a box. He shows with galleries. He works with big brands. He does catalogues for fashion labels, editorials for magazines, and ads for software and mobile phone companies. He does album covers. He creates his own products: t-shirts, adhesive tape with patterns, a Mike Perry snowboard for Salomon, a Mike Perry Iron-On kit for Chronicle Gifts, Mike Perry cushions, mugs, plates, and even a Mike Perry bandage strips box for Urban Outfitters. His books, Hand Job and Over & Over, both published by Princeton Architectural Press, have sold so well they have been reprinted more than once. He has started his own magazine, Untitled. He has even turned his hand to poetry.... And, amid all this, he finds time to reply to my emails – on the same day, as it happens. How does he do it?

Népstadion

Chronicle Display Roman

Elephant. Double Spread and detail of *Parry* typeface used in actual size. Number 1. Winter 2009-2010.

MIND THE STICKS IN

THE NEW COLLAGE MOVEMENT
By Richard Brereton

In the digital age – with images created on a computer tending to look like just that: images created on a computer – some creatives are turning to more traditional methods of interpreting the world. Technology, economics and politics move at rapid speed and, in response, so does the visual world. Out of this flux, something new has emerged, or rather, re-emerged. Collage.

From co-mission's perspective, the often disparate worlds of art and design can appear disconnected but, occasionally or not, these two worlds are increasingly interconnecting. In truth, in one way or another, they have always been connected. It's just a question of how much you choose to notice.

At first sight, juxtaposing visual elements looks like a new language. Look closer, and it feels strangely familiar. Collage is a reflection of what surrounds us. So much of what is around us is absorbed without even being recognised. When someone highlights those references, adding something of their own, only then are we able to notice what had been lying before us in the first place.

It doesn't matter from which country, or nationality. It may have originated, we are somehow there. It's like giving on a long road trip, and turning into the different to the stations along the way. In-

variably, there is far more that connects us than not. Collage has an immediacy, a sincerity, a visual kick – a kick that doesn't require any explanation. It just translates. Philippe Audreyrosa describes his work as 'hallucinations derived from reality.' He starts off making collages when he found a suitcase of family photographs, and later graduated to scanning pictures of his models, friends and family, seen as collage with envelopes full of individuals. 'The cutting of characters suggests a restless restlessness', he says. 'I imagine them, like drawings with flesh and blood.'

Of course, collage is not new, but it is evolving. French illustrator Serge Bloch recently wrote to me after seeing the Max Ernst collage show at Musée d'Orsay in Paris that apparently Ernst once said, 'It is not the glue that makes the collage.'

'I glue things' Bloch says. 'I glue old pieces of paper I found at the flea market, or

trash tickets that were left behind on the deck of the train station in New York or in Paris; or a photograph of a woman, sometimes beautiful, sometimes artist-looking, or old letters, account books...' he explains. 'It is the combination of different elements, the time when I hunt for these "papers" and collect them, and the time for importation, spontaneity for drawing and gluing!'

Illustrator and artist Mark Lazenby says, 'I always start with words, then I go trawling through boxes and drawers. I use old pages of old maps, bottle labels, old paper, books etc... Any beautiful, badly printed matter of any age, anything discarded and unloved, antique prints, the sacred and the profane.'

Sara Fanelli says collage 'enables me to create an image with several layers, with voices from different contexts.'

Many people collect – or some of us, try not to col-

through boxes and draw
then just go.' He collects
says, 'mainly old paper, bo
etc... Any beautiful, ba
printed matter of any age, a
thing discarded and unlo
antique prints, the sacred
the profane.'

Sara Fanelli says coll
'enables me to create an im
with several layers, with vo
from different contexts.'

Many people collect – o
some of us, try not to col

Parry Normal

Parry is a typeface design of Artur Schmal for OurType. Inspired by the sturdy typefaces of Edmund Fry and Thorowhood, it came out as a rather traditional, heavy slab serif, complemented by an even heavier condensed variant and a series of sanserif capitals.

A 3D effect crafted typeface printed over coloured backgrounds opens the different sections of the magazine.

ELEPHANT MAGAZINE
PART FIVE:

CITIES

Creative City Guide

ELEPHANT MAGAZINE
PART FOUR:

E

Emigre

Editor / Director: **Rudy VanderLans**
City / Country: **Berkeley, California / USA**
Founded in: **1984**
Art Direction / Graphic Design: **Rudy VanderLans**
Dimensions: **variable**
Number of pages: **Variable**
Language: **English**
Periodicity: **it is not published anymore**
Website: **www.emigre.com**

EMIGRE
No.70
The Look Back Issue
SELECTIONS FROM EMIGRE MAGAZINE #1 ~ #69
1984 ~ 2009
CELEBRATING 25 YEARS
In Graphic Design

Emigre

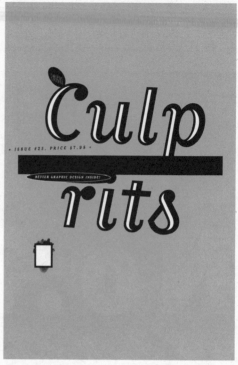

Emigre #19. *Starting from Zero*, 1991.
Cover. 285 x 425 mm.

Emigre #23. *Culprits*, 1992.
Cover. 285 x 425 mm.

Emigre defines itself as simply as possible, as a graphic design magazine. Published in English from 1984 until 2005, with a quarterly circulation, despite its irregularity, its director and designer Rudy VanderLans has a great influence in the design and creation of the publication. His philosophy could be expressed by the idea of starting from scratch in the publication of each number. With regards to size and paper, the magazine is continuously changing.

The first 63 issues were published and distributed by *Emigre* Inc. The following issues, up to a total of 69, were co-published and distributed by Princeton Architectural Press, New York.

One of its clearly distinctive elements is the use of typefaces created exclusively by them, not only because they consider that they are the best, but because they are the magazine's identity mark. The typography has experienced numerous changes throughout the history of the magazine, where "writer type" was the first font used because it was all that the publication

could afford financially at that time. With the introduction of Macintosh in the computer world in 1984 they began to produce their first low-resolution fonts. After the arrival of high resolution and the development of the appropriate software they carried on with the production of their own fonts. Thanks to the popularity and recognition achieved by such creations, they used *Emigre* magazine as a platform for testing and launching these fonts. *Emigre* sustains the magazine on the creation of typefaces.

Despite the use of images or photographs on many of their covers, their use is not considered essential. Not seeing the need to include any other visual element on the cover, these are dedicated to fonts, given that it is a magazine about different fonts.

Given that the magazine format is larger than usual, it is not easily found where one would normally expect to find graphic design magazines. Although the majority of its sales have always been through subscription, the fact that it is a different size, and needs more space

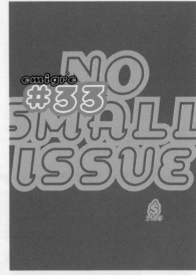

Emigre #33. *No Small Issue*, 1995.
The title of the issue is wordplay: this is the first of
the smaller, revised format reduced to US letter size.
Cover. 215.9 x 279.4 mm.

Emigre #30. *Starting from Zero*, 1991.
Cover. 285 x 425 mm.

Emigre #62.
Catfish, 2002.
Cover.
133 x 210 mm.

because of it, has favoured it in the sense that
having a designated space just for *Emigre* has
given it extra publicity in certain sales outlets.

The magazine can be seen among the
permanent design exhibits of the San Francisco
Modern Art Museum, the Modern Art
Museum in New York, the Cooper-Hewitt
National Design Museum in New York and the
London Design Museum. *Emigre* and Ginko
Press have just published number 70 of the
magazine: a number to remember, where its
25th anniversary is commemorated. It is a book
with a total of 512 pages, which includes the
best of a quarter of a century of *Emigre*
magazine.

FIRST THINGS FIRST

The "First Things First" manifesto (see opposite page) was initially published in January, 1964. This call to arms proclaimed the sentiments of many creatives whose talents were quickly being mulched by the machinery of advertising agencies. Thirty-five years and three reprints later, "First Things First" has become more, rather than less, relevant. "The basis of [this] manifesto was to emphasize what we consider the false priority in spending," stresses participant Ken Garland, "but we also wanted to encourage students, designers and photographers to think about the opportunities for graphic design and photography outside advertising."

FIRST THINGS FIRST

WE, THE UNDERSIGNED, are graphic designers, photographers and students who have been brought up in a world in which the techniques and apparatus of advertising have persistently been presented to us as the most lucrative, effective and desirable means of using our talents. We have been bombarded with publications devoted to this belief, applauding the work of those who have flogged their skill and imagination to sell such things as: Cat food, stomach powders, detergent, hair restorer, striped toothpaste, aftershave lotion, beforeshave lotion, slimming diets, fattening diets, deodorants, fizzy water, cigarettes, roll-ons, pull-ons, and slip-ons.

By far the greatest time and effort of those working in the advertising industry are wasted on these trivial purposes, which contribute little or nothing to our national prosperity.

In common with an increasing number of the general public, we have reached a saturation point at which the high-pitched stream of consumer selling is no more than sheer noise. We think that there are other things more worth using our skill and experience on. There are signs for streets and buildings, books and periodicals, catalogs, instructional manuals, industrial photography, educational aids, films, television features, scientific and industrial publications and all the other media through which we promote our trade, our education, our culture and our greater awareness of the world.

We do not advocate the abolition of high pressure consumer advertising: this is not feasible. Nor do we want to take any of the fun out of life. But we are proposing a reversal of priorities in favour of the more useful and lasting forms of communication. We hope that our society will tire of gimmick merchants, status salesmen and hidden persuaders, and that the prior call on our skills will be for worthwhile purposes. With this in mind, we propose to share our experience and opinions, and to make them available to colleagues, students and others who may be interested.

Edward Wright
Geoffrey White
William Slack
Caroline Rawlence
Ian McLaren
Sam Lambert
Ivor Kamlish
Gerald Jones
Bernard Higton
Brian Grimbly
John Garner
Ken Garland
Anthony Froshaug
Robin Fior
Germano Facetti
Ivan Dodd
Harriet Crowder
Anthony Clift
Gerry Cinamon
Robert Chapman
Ray Carpenter
Ken Briggs

EMIGRE #70: THE LOOK BACK ISSUE | 293 | 1999

Emigre #70. The Look Back issue. Double Spread.

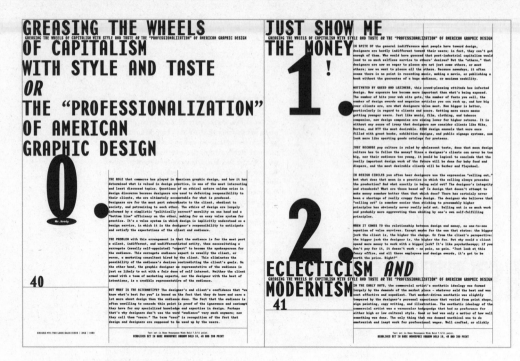

Emigre #70. The Look Back issue. Double Spread.

Emigre #23. Double Spread.

Emigre #26. Double Spread.

Emigre #19. Double Spread.

Editor / Director: **Javier Senón** and **Adrián González**
Country: **Spain**
Founded in: **2009**
Art Direction / Graphic Design: **Folch Studio**
Photography: **Daniel Riera**, **Rafa Gallar**, **Nacho Alegre**, **Xus Antón**, **Ola Rindal**, **Matteo Ferrari, Bela Adler, Salvador Fresneda, Antonio Macarro, Mari Sarai**.
Illustration: **Ricardo Fumanal**, **Izzie Klingels**, **Philippe Jusforgues**, etc.
Dimensions: **215 x 290 mm**
Number of pages: **104**
Language: **Spanish**
Periodicity: **quarterly**
Website: **www.fewmagazine.es**

FEW #02

PRIMAVERA 2009

CLASSIC

IDENTITY

CUSTOM TYPE

p.18
BRUCE LABRUCE
Fotógrafo? Director
de cine porno? Artista?
Quien es Bruce Labruce
y por qué su obra transgresora causa polémica.

p.26
MY BRIGHTEST DIAMOND
Indie rock'n'roll y música
clásica van de la mano
superando todos los
límites de la experimentación en el proyecto musical de Shara Worden.

p.45
LUJO IBERICO
El nuevo lujo está menos
relacionado con los artistas y artesanos, y más
vinculado a un concepto,
el mundo de la marca.

STELLAR
...cio...to de una España
...nci...como un hueso
de ...rón. Las palabras
...e pierden y las
...s que se hereda
...n is different.

WEBSTER HALL
BOWERY PRESENTS
CSS
SSION DEC 12 18

p.79
CANSEI DE SER SEXY
Sin pelos en la lengua,
ellos transbordan ironía
y un espíritu "viva la fiesta";
CSS es auténtico pop,
pero con la pata indie.

p.96
BAZAR
Irónicas piezas de pret-
à-porter que juegan a
reivindicar la supremacía
del hombre ante la
máquina.

The typeface in use *FS Ugly*, custom designed by Miquel Polidano and Reto Moser from Folch Studio, in 2008. This typeface is used to differentiate the fashion section.

Folio is the font family used in this spread. It was designed in 1957 by Konrad F. Bauer and Walter Baum for the Bauer foundry. *Folio* font was chosen because it is very versatile and works well with small letters for blocks of text as in the condensed version for headings and highlighted elements.

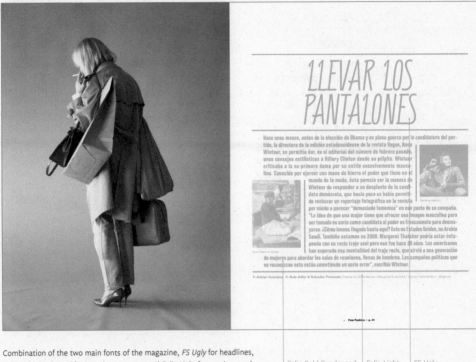

Combination of the two main fonts of the magazine, *FS Ugly* for headlines, *Folio Bold Condensed* for introductory texts and *Folio Light* for captions and page numbers.

Folio Bold Condensed | *Folio Light* | *FS Ugly*

Few, a quarterly magazine about trends, comes to us in Spanish from Folch Studio in Spain, with contents related to photography, fashion and journalism. The interplay of typography, layout and image is what gives personality to the magazine, combined with an original use of colour. The latter plays an essential role in the design of the magazine, as they add a colour which might be termed a guest, to the basic structure of each number, which serves not only in the ranking of the information but to also differentiate each issue.

The manner in which the horizontal and vertical lines are combined with the images, along with the typography, gives the publication a journalistic character and a language of its own for the written press. The articles and interviews are emphasised by this style and these together with fashion are the two most important sections of *Few*.

The unique character and personality of *Few* are mainly due to the typography designed by the studio. The magazine has a main article related to the fashion world which is differentiated by a matt-coated paper that contrasts with the offset volume of the rest of the publication.

Folio is the main font and ***FS Ugly*** is specifically for the fashion section. *Folio* font was chosen because it is very versatile and works well with small letters for blocks of text as in the condensed version for headings and highlighted elements. ***FS Ugly*** helps to differentiate the fashion section perfectly from the rest of the magazine and gives it a more personal character.

O EL ENCANTO DE UNA ESPAÑA RANCIA, COMO UN HUESO
DE JAMÓN. LAS PALABRAS QUE SE PIERDEN Y LAS PERLAS
QUE SE HEREDAN. SPAIN IS DIFFERENT.

FOTOS TOMADAS EN BOTÍN, EL RESTAURANTE MÁS VIEJO
DEL MUNDO. CUCHILLEROS 17, 28005 MADRID WWW.BOTIN.ES
"BOTÍN PARECE QUE HA EXISTIDO SIEMPRE Y QUE ADÁN Y EVA HAN
COMIDO ALLÍ EL PRIMER COCHINILLO QUE SE GUISÓ EN EL MUNDO".
RAMÓN GÓMEZ DE LA SERNA, DE "GREGUERÍAS".

LA FLOR
DEL AZAFRÁN

Foto: Rafa Gallar / Realización: Adrián González
/ Maquillaje: Jean Delmonte de Cool para Bobbi Brown / Pelo: Manu Fernández de Cool para Kiehls
/ Asistente de foto: Dani Gallar / Asistente de realización: Jaime Calastrova
/ Modelos: Katija Buscher, de Views; Alicia Padrón, Almudena Remay y Vanesa Madraza.

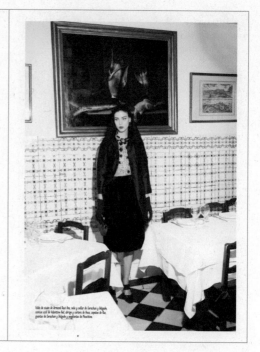

Falda de raya de Armand Basi line, velo y collar de Cornejora y Delgado,
camisa azul de Valentino Red, abrigo y cartera de Hoss, zapatos de Vas,
guantes de Cornejora y Delgado y pengdientes de Macchine.

The typeface used is the *FS Ugly*, that is also used in issue number 02 of the journal, but in a different fluorescent ink color.

A LUCHA CONTRA EL SUEÑO.
ATISBOS CONMOVEDORES
REALIDAD ANIMAL, AGAZAPADA
O LATENTE, BAJO LAS FAUCES
EL MÁS EXQUISITO CONTROL.

———

Foto: Rafa Gallar
Realización: Adrian González
Maquillaje: Gato para Maybelline New York
Pelo: Daniel Martin de Biggmonkey

opciones posibles pare-
arato o bastante más
medio está en vías de
has categorías.

Bernard Arnault -ahora a la c
escena. "Un hombre de negoc
tificando el sector del lujo con
genes de ganancia de lujo", ab
estrella más y las convirtió en
base de gastarse cientos de m
alfombra roja, "estampar el log
y posicionar el producto en du

La perversa realidad del consum
la mayoría clama por lo que Thom
jicamente, paralelo a la desparici
del consumidor, y no sólo el de la
contemporáneo en publicidad, di
democratización del lujo, hacien
disponibles al cliente medio mun

hecho
ha tra
de 15
que as
a nive
la sofi
bió en
nuevo

Detail of *FS Ugly* in actual size.

Detail of *FS Ugly* and *Folio* in actual size.

Así, tanto las colecciones de prêt à porter como el caro café de Starbucks serían nuevos lujos, lujos que se retiran al tradicional y conviven junto a otra tendencia contraria: la presión en precios que muchos bienes tienen que soportar. Las dos únicas opciones posibles parecen ser o muy barato o bastante más caro; el término medio está en vías de extinción en muchas categorías.

En el artículo "Cómo el lujo perdió su brillo", Dana Thomas, corresponsal en París de Newsweek y Harper's Australia, explica lo que la moda fue y en lo que se ha convertido, documentando cómo un segmento de la industria que alguna vez estuvo orientado a proporcionar los mejores bienes hecho a mano a manos a los pocos que podían pagarlos se ha transformado en una "vaca de efectivo global" de 157.000 millones al año, una mega-empresa que asigna una prima mucho mayor al marketing a nivel mundial que a la calidad, el buen gusto y la inflatiación exclusiva. Según Dana, todo cambió en las últimas décadas del siglo 20, cuando un nuevo tipo de proveedor de lujo, epitomizado por

las dos únicas opciones posibles parecen ser o muy barato o bastante más caro; el término medio está en vías de extinción en muchas categorías.

Bernard Arnault -ahora a la cabeza de la multibillonaria LVMH-, llegó a escena. "Un hombre de negocios, no un hombre de moda", Arnault, identificando el sector del lujo como "el único en el que se podría hacer márgenes de ganancia de lujo", absorbió Dior, Vuitton y unas cuantas marcas estrella más y las convirtió en marcas de deseo del consumidor global a base de gastarse cientos de millones en publicidad, vestir celebrities en la alfombra roja, "estampar el logo en cualquier cosa desde bolsos a biquinis" y posicionar el producto en duty frees y franquicias de todo el mundo.

La perversa realidad del consumo de lujo hoy es que muy poca gente se queja y la mayoría clama por lo que Thomas se refiere como "un trozo del sueño". Paradójicamente, paralelo a la desaparición de los artesanos está el aumento del apetito del consumidor, y no sólo el de la originaria y elitista clientela. El vasto crecimiento contemporáneo en publicidad, distribución y product-placement ha afectado a la democratización del lujo, haciendo a las marcas que una vez fueron exclusivas disponibles al cliente medio mundial, aunque sea en forma de zapatillas y gafas cubiertas de logos.

Como resultado, una chaqueta o bolso de diseñador no transmite información fiable sobre el background o status socioeconómico del que lo lleva. La autora se descubre absorta ante la imagen de una mujer "con pantalones de diseñador, buena joyería y unas gafas de Chanel" mostrando interés en un Rolex falso. O una pareja metiendo bolsas en un coche de 380.000 dólares, descubriendo después que la procedencia de dichas bolsas es un Outlet cercano. A este pasaje, sigue en la obra de Thomas unos comentarios sobre los últimos días de la República Romana, contrastando la era de despegue del nuevo rico con una anterior y más "patricia", donde la "gente solía conocer su sitio".

El lujo ya no es una experiencia privada y privilegiada, sino pública, superficial, siempre cambiante e infinitamente disponible, lo que viene a tener poco que ver con lo que debería ser el lujo. Hoy en día, lo que estamos comprando cuando compramos una marca de lujo no es una experiencia o una calidad, sino que estamos comprando un concepto el mundo de la marca. Sin embargo, no es que debamos volver a los días en que pocas personas podían permitirse adquirir cosas buenas, pero el quizá estar más atentos a las técnicas de comercialización que tratan de explotar nuestro apetito por esa imposibilidad que supone el lujo. Thomas expone que gran parte de la mística detrás de productos de lujo se basa en la exposición de que son hechos a mano por artesanos europeos. Pero los hechos desmienten la mística. Louis Vuitton, una empresa que genera 3.000 millones al año por sus trabajos en cuero, anunció recientemente sus planes para construir una fábrica

Vaqueros De Jon DB del archivo del museo Lanvin, top vintage de Carachán y Delgado, zapatos vintage y bolso de soporte de Exportoria Toledo.

Camiseta De Carlucho, vaqueros vintage del archivo del museo Lanvin y zapatos vintage.

CANSEI DE SER SEXY
Bittersweet pop flavour

En su música, en su look y sobre todo en su actitud está estampado: "somos cool, somos extravagantes, somos CSS". Lo que adquiere al fin y al cabo es hacer bailar y divertirse a la gente. Una forma acertada de describir lo que es esencialmente la música pop. No los juzgués si crees que lo que escuchan es cursi o grillado; Gipsy Kings está en su playlist, ¿y qué? Ellos no se cansan de pasarselo bien.

T: Carolina Suárez Marchi F: Miguel Villalobos

Futu

Editor: **Martyna Bednarska-Cwiek**
City / Country: **Warsaw / Poland**
Founded in: **2005**
Art Direction / Graphic Design: **changes in every issue**
Dimensions: **230 x 280 mm**
Number of pages: **240**
Languages: **Polish / English**
Periodicity: **twice a year**
Website: **www.futumag.com**

Futu. Cover, Number 6. "Label". Designed by Matt Willey / Studio 8 Design, 2008.

IT'S WHAT YOUR RIGHT ARM'S FOR

WE DO IT YOUR WAY

WE KEEP YOUR PROMISES

HEAD FOR THE BORDER

ONE LEG AT A TIME

WE'RE NUMBER TWO. WE TRY HARDER

WOT A LOT I GOT

FINGER-LICKIN' GOOD

WHILE IN EUROPE, PICK UP AN UGLY EUROPEAN

A LITTLE DAB'LL DO YA

CLEANS ROUND THE BEND

GEE, I WISH I HAD A NICKEL

JUST IMAGINE

LIVE TODAY. TOMORROW WILL COST MORE

ONLY 1 OUT OF 25 MEN IS COLOR BLIND. THE OTHER 24 JUST DRESS THAT WAY

STOPS HALITOSIS!

MAKE YOURSELF HEARD

TASTE AS GOOD AS IT SMELLS

WE SELL MORE CARS THAN FORD, CHRYSLER, CHEVROLET, AND BUICK COMBINED

LIMITED EDITION OF UNLIMITED IDEAS

PURE GENIUS

IT IS. ARE YOU?

SOFT, STRONG AND VERY LONG

PREPARE TO WANT ONE

IT'S SO BIG, YOU'VE GOTTA GRIN TO GET IT IN

THINK DIFFERENT

HELLO BOYS

BLOW SOME MY WAY

THE GENUINE ARTICLE

COME TO WHERE THE FLAVOR IS

Futu. Cover, Number 8. "Sustainability".
Designed by Frost Design, 2009.
The idea behind the magazine begins on
the cover with 'futu' turning into 'future'
which is the critical issue in question.
Then starting with the thin line as the
outline of the font and minimal ink on
the page, we adopt a simple sustainable
metaphor- that less is more. This grows
into the idea of 'walking the line' and the
need to get the balance right between
ecology and economy.

Few magazines offer art direction and graphic design that change with every issue they publish. *Futu* comes from Poland and is published twice a year in English and Polish, with an international profile. *Futu* gives us a new vision of design, photography, fashion and luxury, combining the most advanced techniques in publishing and the latest trends in graphic design and typography. As a distinctive feature of the magazine, we would like to stress that the most important studios in the design world have worked on its creation.

The magazine works with studios that are able to create the concept of visual cohesion, while providing them with an unprecedented creative independence. Taking a different approach in each issue, the magazine acquires a new quality in the hands of today's most interesting designers. ***Champion, Chaparral***, and ***Fat Face*** are the fonts we find on the pages of *Futu*. Its innovation comes in the distribution of the magazine, which is presented in a box.

"Label" number 4 of the magazine, winner of wide recognition and prizes, designed by Matt Willey, serves as an example. Inside there is an analysis of the phenomenon of the global brands, movers and shakers of the global economy, and small local brands that are limited to supplying the special needs of their customers. It mainly focuses on those influential brands with which we have a strong identity, how they are created, how they work and how they are able to affect the economy.

The next "Luxury" issue was designed in Barcelona by Albert Folch; the last "Sustainability" issue, created by Vince Frost comes from Sydney. We could define it at as a "blueprint for our future;" it's the time to walk on eggs and walk the fine line that separates economy from ecology and consumerism from conservation. This idea was achieved with a simple metaphor, with a key typography and minimal use of ink on each page, i.e. the basic philosophy of "less is more." In this aspect, we have to include the fact that the magazine was printed on environmentally friendly paper. Apart from that, sixteen pages of the magazine were assigned to eight NGOs selected at an international level, focusing on sustainability and the fact that they desperately need our help. Frost Design created a unique concept in graphic design making "Sustainability" the best-defined idea.

Gdyby sytuować obecność Zahy Hadid w zbiorowej świadomości, jej pozycja bliska jest tej, jaką osiągnęły torebki Prady

If we were to locate Zaha Hadid in our collective consciousness, she would be somewhere in the vicinity of Prada handbags

Champion *Fat Face*

At Futu 6 the *Champion* family typeface by Hoefler & Frere-Jones is used for the headlines design, in this case mixed with *Fat Face*. *Chaparral Pro* (Adobe) is used for the bilingual texts in English and Polish.

Fat Face *Chaparrral*

The pallete colour is restricted to red and black, which is strong and simple. Two headline typefaces give a certain sort of indentity.

Sustainability is a blueprint for our future. It's time to tread lightly and walk the fine line between economy and ecology, consumerism and conservation.

In creating Futu 8: Sustainability Frost*Design adopted a simple metaphor – through key-line typography and minimal ink on the page – that less is more.

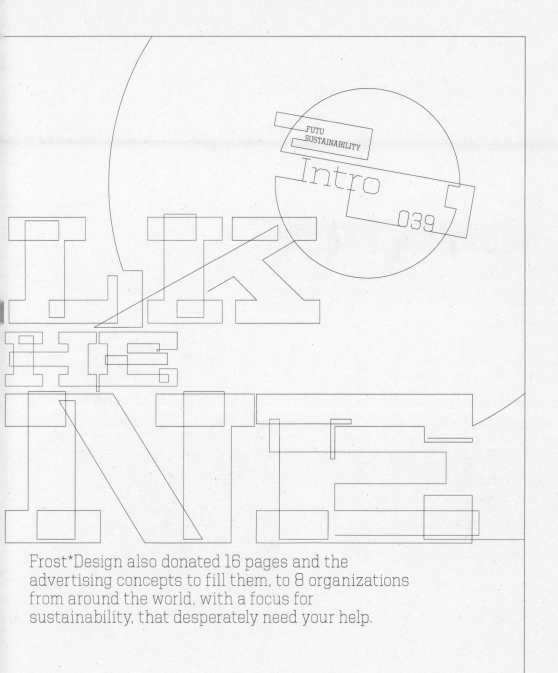

FUTU
SUSTAINABILITY

Intro

039

Frost*Design also donated 16 pages and the
advertising concepts to fill them, to 8 organizations
from around the world, with a focus for
sustainability, that desperately need your help.

Futu. Double Spread, Number 8. "Sustainability". Designed by Frost Design, 2009.

It is no coincidence that such an approach is associated with Japanese culture. Kenya Hara refers to his own heritage consciously; his local sensibility is a starting point that enables him to create objects. He claims to draw inspiration from his birthplace. This is not to say that he is a traditionalist. The visual identification project he designed for the Beijing Olympic Games looks downright cosmic; it has no ties to any of the dominating trends in visual arts. The effect of foreignness is a result of the transference of anachronistic, historical stylistic elements into a new modern context. The result is astounding: a nostalgic effect mixes with a feeling of harmony which dominates in the end, coexisting with a rare elegance. It is in this manner that Japanese culture succeeds in applying that which belongs to the past, without resorting to stylistic gymnastics, as it sometimes does nowadays, when the advent of digital technologies has made it possible to reproduce baroque forms. As we gaze at Kenya Hara's project, we gradually comprehend how the present can result from the past, how one can melt into the other.

Although the term "harmony" best describes Kenya Hara's work, his primary goal is to refresh our perspective on things, to evoke emotions, sometimes even shock. He achieves these ends through solutions that go beyond the purely visible. One characteristic element of Hara's style is that the importance of the surface of an object does not lie solely in its appearance, but also in the tactile sensation that it evokes. At an exhibition he organised, titled Haptic [Kenya Hara is not only a designer, but also an art director, curator, and exhibition designer], one of the most interesting exhibits was a series of juice boxes designed by Naoto Fukusawa. The materials used to construct them were shaped to resemble fruit skin. The kiwi juice box was covered in fuzz, while the banana juice tempted would-be buyers in a box topped off with what looked like a banana tree branch. While these projects seem, at first glance, to depend on their surprising appearances, their true effect is felt through the sense of touch. The characteristic texture is immediately discernible; something makes us want to touch the box that is like no other standard carton. The man-made object bears an uncanny resemblance to natural fruit, and the touch is more important than the sight. »

Tego rodzaju podejście nieprzypadkowo kojarzy się z kulturą japońską. Kenya Hara świadomie odnosi się do własnego dziedzictwa; lokalna wrażliwość jest dla niego punktem wyjścia, dzięki któremu może tworzyć przedmioty. Jak mówi, oryginalność czerpie z miejsca w którym się urodził. Nie znaczy to jednak, że jest tradycjonalistą. Przygotowany przez niego projekt identyfikacji wizualnej Igrzysk Olimpijskich w Pekinie wygląda jak z innego świata - nie nawiązuje do żadnego z dominujących trendów graficznych. Ten efekt obcości wynika z przeniesienia anachronicznych, historycznych z historią elementów stylistycznych w nowy, współczesny kontekst. Rezultat jest zaskakujący: wrażenie nostalgii miesza się z poczuciem harmonii, które ostatecznie dominuje, współistniejąc z rzadko spotykaną elegancją. W ten sposób działa właśnie japońskiej kulturze umiejętność korzystania z tego, co przeszłe bez kopiowania czy uciekania się do karkołomnych efektów stylistycznych, tak jak współcześnie, kiedy to na przykład dzięki cyfrowym technologiom reprodukuje się barokowe formy. Kiedy oglądamy projekt Kenya Hary, stopniowo zaczynamy rozumieć, w jaki sposób współczesność może wynikać z przeszłości, w jaki sposób może się z nią stapiać.

Choć harmonia w najlepszy sposób charakteryzuje realizacje Kenya Hary, jego najważniejszym celem jest odświeżanie naszego spojrzenia na rzeczy, wywoływanie emocji, a nawet szoku. Te efekty osiąga dzięki rozwiązaniom, które nigdy nie mają charakteru czysto wizualnego. Oto charakterystyczna cecha stylu Japończyka: powierzchnia przedmiotu nie jest istotna tylko i wyłącznie ze względu na jego wygląd, lecz także ze względu na wrażenie dotykowe, które wywołuje. Na zorganizowanej przez niego wystawie zatytułowanej Haptic [Kenya Hara jest nie tylko projektantem, ale też art directorem, kuratorem i projektantem wystaw] jednym z najciekawszych eksponatów była seria kartonów do soków zaprojektowanych przez Naoto Fukusawę. Użyte do ich wykonania materiały ukształtowano tak, by przypominały skórki owoców. Karton soku kiwi pokryty jest drobnymi włoskami, natomiast sok bananowy czeka na swego nabywcę w opakowaniu zwieńczonym elementem przypominającym zdrewniałą łodygę bananowca. Te projekty, choć w pierwszej chwili wydają się oparte na niezwykłym wyglądzie, tak naprawdę działają przede wszystkim ze zmysł dotyku. Już na pierwszy rzut oka możemy zauważyć charakterystyczną fakturę; pragniemy dotknąć powierzchni, które nie ma nic wspólnego ze standardowymi kartonami. Wytworzony przez człowieka przedmiot do złudzenia przypomina naturalny owoc, a dotyk jest ważniejszy niż wzrok. »

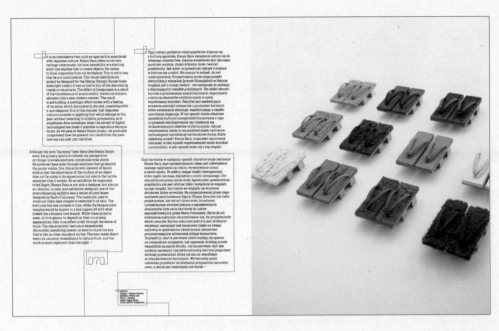

Frost's editorial work is known for its use of big wood block typography and dense design. This issue of Futu has provided Frost with the perfect vehicle to be calmer; it's a simple set up. Images can be colour, all text is black and fine.

'If ink were not a magazine, it would probably be a workshop for conferences and meetings'

Editor / Director: **Ink magazine - Pierre Delmas Bouly** and **Patrick Lallemand**
City / Country: **Lyon / France**
Founded in: **2006**
Art Direction / Graphic Design: **Superscript (www.super-script.com)**
Dimensions: **190 x 260 mm**
Number of pages: **64**
Language: **French**
Periodicity: **1 – 2 a year**
Website: **www.ink-magazine.com**

ink

$\frac{20}{200}$	A U	$\frac{200\ ft}{61\ m}$
$\frac{20}{100}$	T O U	$\frac{100\ ft}{30.5\ m}$
$\frac{20}{70}$	R D E L	$\frac{70\ ft}{21.3\ m}$
$\frac{20}{50}$	A L I S I	$\frac{50\ ft}{15.2\ m}$
$\frac{20}{40}$	B I L I T É	$\frac{40\ ft}{12.2\ m}$

CLASSIC

HEADLINE DESIGN

DESIGNER

Ink. Cover number 1. May 2007.

Ink. Cover number 2. November 2007.

The team of *ink*, a magazine from France that was founded in 2006, consists of a wide range of participants including photographers, graphic designers, journalists, teachers and students. Its creators define it as a "participative magazine about graphic design and typefaces." The term "participative" is substantiated by the fact that the fundamental objective of the magazine is to act as a channel for the exchange of constructive ideas and to provide a place for sharing and enjoying a multi-dimensional approach to the graphic design concept, covering both its theoretical and visual aspects. Dealing with different themes published in the form of topics of interest, the magazine explores a wide range of sectors which may be of potential interest to graphic artists (fonts, images, photographs, title sequences, video design, digital media, etc.). *ink* explores graphic design like a field of research and creation, as seen by those related to this sector (professionals, students, theorists, journalists, etc.).

Defining a magazine is very complex, as each one is different. A good magazine can be created about very different issues; everything may be of interest or cease to be so. Creating a magazine may become a structured editorial experience, part experimentation, with requirements to be met, and inquisitive, that asks questions, with contributions. *ink* is like a playground for its creators to experiment. If *ink* were not a magazine, it would probably be a workshop for conferences and meetings.

The name of the magazine, *ink*, is part of that game and the experiment. After drinking and having finished the first issue, its creators still had no name for the magazine. When they awoke the next morning with a terrible hangover, someone saw a short description on an ink cartridge, and it was then when the word *ink* appeared as a revelation.

The magazine has no header, layout or defined image. With each issue they try to find original graphics in comparison to the previous. In an attempt to maintain that individuality, they try to find different ideas for layout, headings or paging. The typography/layout/image triangle is a very important concept, but each separate aspect is of vital importance.

ink is a graphic and typographic magazine. It is very important for the creators to use this editorial project to experiment and take various possibilities into account in layout terms, or choice of printing paper for the next issue.

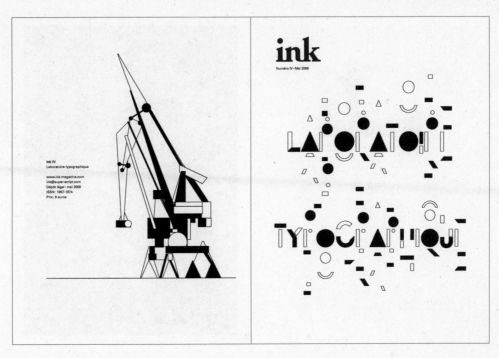

ink. Cover and backcover. Number 4. May 2009. This issue was carried out with Jocelyn Cottencin and The Art School in Lorient.

Ink. Double Spread. Number 2. May 2007. Designed by Thomas Huot Marchand.

ink. Double Spread. Number 4. May 2009. Designed by Thomas Bizzarri.

Graphic design and typography are the two main pillars of this project.

ink is a creative process that is continuously changing and maintaining this aspect is of great importance. All viable changes are considered and dealt with without fear; there is nothing fixed or established, nothing to regret, no intention of making *ink* the perfect issue. Each issue can be better than the last, everything can always be better.

Regarding typography, *ink* opts for a change in each issue. Starting with the last issue, they decided to contact a type designer who presented one of their creations or projects and use the magazine to launch or test it. For the last issue, the magazine used the French designer, Jean Baptiste Levée (www.opto.fr). A few months ago, they were given the idea of a reissue of a font called *Acier* by the prestigious French designer Cassandre. They liked the idea and decided to give it a place in the magazine.

ink offers a publication with a lot of possibilities. *ink* offers a magazine where everything can be changed and where they still believe that anything can always be improved from one issue to another. Each cover is different and this is part of their module project. However, there is something that is always there: the logo. They consider having a fixed visual element in each issue to be very important. This element is more than enough to have an easily recognisable cover for loyal fans.

ink. Interior Cover. Number 4. May 2009. Jean-Baptiste Levée, reissued of a font called *Acier*, by the prestigious French designer Cassandre.

'The most melancholy magazine'

Kasino A4

Director: **Pekka Toivonen**
Editor: **Jonathan Mander**
Photography: **Jussi Puikkonen**
Production: **Antti Routto**
Country: **Finland**
Founded in: **2005**
Art Direction / Graphic Design: **Pekka Toivonen**
Dimensions: **210 x 297 mm** (A4)
Number of pages: **124**
Language: **English**
Periodicity: **it is not published anymore**
Website: **www.wearekasino.com**

KASINO

KASINO A4 MAGAZINE ISSUE #9 SPRING / SUMMER 2009

A4

E MOST MELANCHOLY MAGAZINE

EU €7 GB £7 US $14.50

Kasino A4 is probably the gloomiest magazine that can be found on sale. Published in English, this magazine, from Finland, is something very personal for its creators. Its origins date back to 2005, when they set out to create the gloomiest magazine possible, taking this state of gloom so characteristic of the Finnish mentality as their starting point. This could be said to be the real philosophy of the magazine, this gloomy look that they wish to highlight. They dare to say, that if *Kasino A4* were not a magazine, it might possibly be a terror theme park. Starting from this perspective or with this idea, their intention, without a doubt, is to explore the world. The key words that may define the magazine are: intimate, authentic and uncompromising. It also gives us a sharp view, speaks for itself and delights us with a human touch which is so evident in its design and content. In a world of chaos and frenzy, this ingenious publication is presented like delicious food cooked on a low heat, where every morsel of inspiration is worth savouring because it may make you laugh or cry.

With an original team of three, *Kasino A4* has increased the number of participants, but thinks it is important to maintain a small team to maintain the intimate atmosphere and the immediacy of the magazine. The magazine was founded by a photographer, a graphic designer and a writer who decided to form a team to join their talents in just one media: a magazine.

The creation of *Kasino A4* comes from the sharing of ideas. After a few months in which ideas, inspiration and energy come together, the magazine is produced in a month. Four people and a group of eight permanent reliable contributors achieved all this.

With regards to the external aspect of the magazine, the result of factors such as typography, layout and image is of relevant importance. In general, we can find a broad extensive use of images that makes *Kasino A4* consider itself to be very photographic, but a strict layout and well chosen typography does the rest in making the space designed for content and images. Everything is done in a

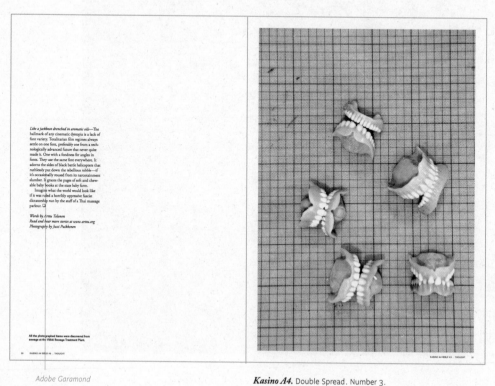

Adobe Garamond

Kasino A4. Double Spread. Number 3.

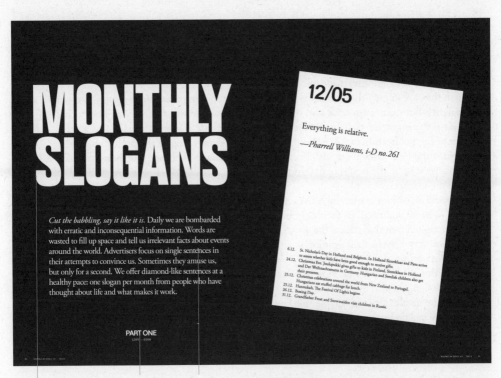

MONTHLY SLOGANS

Cut the babbling, say it like it is. Daily we are bombarded with erratic and inconsequential information. Words are wasted to fill up space and tell us irrelevant facts about events around the world. Advertisers focus on single sentences in their attempts to convince us. Sometimes they amuse us, but only for a second. We offer diamond-like sentences at a healthy pace: one slogan per month from people who have thought about life and what makes it work.

PART ONE
(2007 – 8506)

12/05

Everything is relative.

—*Pharrell Williams, i-D no.261*

6.12. St. Nicholas's Day in Holland and Belgium. In Holland Sinterklaas and Piets arrive to assess whether kids have been good enough to receive gifts.
24.12. Christmas Eve. Joulupukki gives gifts to kids in Finland, Sinterklaas in Holland and Der Weihnachtsmann in Germany. Hungarian and Swedish children also get their presents.
25.12. Christmas celebrations around the world from New Zealand to Portugal.
25.12. Hungarians eat stuffed cabbage for lunch.
25.12. Hannukah. The Festival Of Lights begins.
26.12. Boxing Day.
31.12. Grandfather Frost and Snowmaiden visit children in Russia.

Folio Bold Condensed Folio Medium & Light Adobe Garamond **Kasino A4.** Double Spread. Number 0.

BACK2MASKU

ONE CITY GIRL RETURNS TO THE SMALL TOWN OF MASKU SHE WAS RAISED IN. A DRAMA OF JEALOUSY AND LUST INVOLVING FOUR PEOPLE ENSUES.

IN CO-OPERATION WITH MINUS & MY O MY

PHOTOGRAPHY JUSSI PUIKKONEN
STYLE AINO OKSINO & RAYMUND HANNEN
MODELS KERO YLI-HANKURI, JANNA – AZCHRO,
KALLE : PAPARAZZI & TIKI

Folio Bold & Regular Bordeaux Roman Bold **Kasino A4.** Double Spread. Number ABC.

global way in the magazine, with no different departments separating content from design.

Something that makes *Kasino A4* a magazine with a special design is the fact that it is in black and white and uses a specific paper for which they are known that has been part of its popularity. Someone even once said that *Kasino A4* is the magazine that smells the best! The size of the publication is A4, not only because it is the most typical but also because they consider it to be the best size design that exists on the market.

Garamond is the font chosen by *Kasino A4* for texts and *Folio* for additions. In their opinion it is a well-designed font that makes the artistic director's job very easy. In their opinion *Garamond* is perfect. With no foreseeable changes in this aspect, their intention is to leave the entire design just as it is.

Unlike the inside of the magazine, the cover of *Kasino A4* has no images. This is something which is deliberate and done with the intention of making it stand-out from all other available publications. They consider that this is the best way to be different and attract the attention of the potential magazine buyers. With no fear of not being seen, their motto is "if people don't find us, we will find them." The decision to distribute it internationally was a very important step in the projection of the magazine. Another was their first exhibition in August 2006. With the title "330 Prints, 80 moments and a magazine – The full story", the exhibition was able to adapt their concept to a completely different media.

The magazine contents are limited to those topics which, in their opinion make up a good magazine: people, thoughts, style and lots of fun. The secret to the success of the publication is their non-commitment, which leads many creators to turn to it in search of new ideas which *Kasino A4* offers in an independent way.

ATTITUDE MAKES A MAN. WE FITTED BUSTER WITH SOME STYLISH ADULT THREADS AND—VOILÀ—BIG BECOMES BEAUTIFUL AGAIN

Kasino A4. Double Spread. Number 3.

Folio Light

This is where I stayed

Kasino A4. Double spread. Number 0. Detail in actual size.

THURSDAY SEPTEMBER 28, 2006 22:17

I was born in Paris, my mother's Finnish and my Dad's Algerian. I moved to Finland with my Mum when I was five. This morning I noticed I miss my father more than usual. I made Algerian food at home, the tastes and smells usually help my longing. The civil war and unrest have continued in Algeria for 15 years, so it's not safe to travel there and I meet my Dad either in Paris or Helsinki. He's coming over in a month and I can't wait! Whenever he's here I feel strangely and wonderfully safe, just like a child who doesn't need to take care of anything. At that moment there are no dangers in the world and someone's always on my side taking care of me!

FRIDAY SEPTEMBER 29, 2006 22:21

I was flat-hunting all day, but didn't see anything that felt like my possible home. That home is high, full of light and in an old building. The

Kasino A4. Double Spread. Number 3. Detail in actual size.
The use of *Garamond* has to do with the melancholy mood and the melancholy look the art directors want to emphasize.

Laser Magazine

Editor / Director: **Nicole Klein**, **Tina Kohlmann**, **Michael Satter** and **Tina Schott**
Country: **Germany**
Founded in: **2005**
Art Direction / Graphic Design: **Nicole Klein** and **Michael Satter**
Collaborators / Num. 1: **Thomas Berger, Isabelle Fein, Gina Mönch, Michael Satter** and **Maria Tackmann** / Num. 2: **Nina Jan Beier and Marie Jan Lund, Florian de Brün, Anna Giertz, Hui Hui Fashion, Claus Richter, Daniel Sannwald, Tina Schott, Szpilman Award, Vier 5** and **Nessie de Witte**
Dimensions: **200 x 287 mm**
Number of pages: Num. 1: **46 pages** Num. 2: **82 pages**
Languages: **German** and **English**
Periodicity: **every two years**
Website: **www.lasermag.de**

Laser Magazine. Number 02. September 2007.

10 Euro www.lasermag.de

LAS
ER

Magazine Nr. 02

Laser Magazine may be considered a contemporary document, as its content and design are highly topical and on everybody's lips. The publication, which comes from Germany, in English and German, responds to a carefully chosen acronym with a significance that leaves no one indifferent, "Light Amplification by Stimulated Emission of Radiation," or what amounts to "Light Amplified by a Stimulated Emission of Radiation." With such a suggestive title, we find a publication that shows almost everything together at a given time which may be beautiful or interesting. The magazine presents works of art, artists, ideas and topics of all kinds. The light from the magazine is like a ray that surrounds and illuminates a point of interest, which is just a small sample of what is happening around us; as if they would like to show all subjects of interest that are around us in a single issue.

All elements are equally taken into account in the design of the magazine. The importance of the choice of title rests equally on the typography, page layout and image. Nicole Klein and Michael Satter, director and designer, consider the fact that they are responsible for designing and directing it themselves of paramount importance. Their influence on the magazine is essential and is reflected in a unique design and a good blend of highs and lows.

Laser Magazine is characterised by its very rational use of typefaces. **Laser Regular** was the typeface chosen for the first issue of the magazine, while for the second issue that choice fell on **Laser Spray**, **Times Ten** and **Courier New**. They opted for **New Johnston** and **Albertus** in the third issue. These fonts offer a functionality that fits in with the magazine's characteristics. The philosophy of the typographical change in the second issue quite simply responds to text type reasons. The second issue presented a larger quantity of text and it was decided to use **Times Ten** because of its versatility in large and small bodies of text. From the designers' point of view, **Times Ten** is perfect for the job. In the field of printing, the magazine has its own creations, something which aims at giving it that special character, which can be found throughout the magazine. The mixture of custom designed fonts such as **Laser Regular** and **Laser Spray**, used on the cover, give it the peculiarity of exclusivity.

An element as important as the cover should not be left to one side, and *Laser Magazine* tries to express an attitude and an unconventional feeling with its front pages. We can find a multitude of magazines on the market with enormous photographs on the cover. *Laser Magazine* thought that it would be much more interesting to occupy the front page with the name of the magazine only.

The creation and publication of *Laser Magazine* is not due to commercial interests, not with a magazine that concedes the possibility of playing with the design to the creators. That is why each issue of *Laser Magazine* appears as an independent element in a big project in the making.

Chaumont

Haunted Mansion Paris

Ein enger Aufzug beförderte die Mitarbeiter in den oberen Bereich des Gebäudes, um dort dann im inneren Stahl-Betongehäuse eines verzauberten Fantasy-Schlosses ihre Arbeit zu verrichten.

Seit ich von diesem geheimen Raum weiß, war mein größter Traum, dort einen Fantasyfilm über Ludwig II. zu drehen. Doch die Dinge haben sich geändert.

Furnishing the magic rabbit hole
Wir schreiben das *„Year of a million Dreams"* in Walt Disney World. Im Verlauf dieses Jahres sucht die Disney Company per Zufallsprinzip insgesamt eine Millionen Besucher des Themenparks aus, und überrascht sie mit außergewöhnlichen Erlebnissen. (Einen ganzen Tag lang Disney World für sich alleine haben, Reisen, speziellen Zutrittsrechten zu den Attraktionen etc...).

Und so kam es, dass unter der Leitung von Stephen Silvestri der kahle Betonraum im Obergeschoss des Cinderella Castles zu einer prächtigen Suite umgebaut wurde, in der jetzt Nacht für Nacht ein glücklicher Parkbesucher mit 4 Freunden wohnen darf.

Interessant ist, dass der Aufenthalt in der magischen Suite nicht durch Geld gekauft werden kann, allein das Los entscheidet wer ins Schloss ziehen darf. Gerade diese Verlagerung von Exklusivität durch Geld hin zu Exklusivität durch einen *„magischen Zufall"* finde ich einen gelungenen Schachzug in der Etablierung einer verzauberten Parallelwelt. Wie gut die Schachtelung der Illusionen im

Innen- und Außenraum geplant ist, zeigt ein Zitat von Stephen Silvestri:
„We want our guests to feel as though they are inside our castle but also immersed within the fantasy realm of the Cinderella story."
Nun also wuchert die magische Oberfläche der Attraktionen weiter in deren Inneres und erschafft dort, ähnlich wie beim *„Phantom Manor"*, dass Innen größer als außen ist, einen doppelt codierten Raum.

Man betritt mit der Luxussuite des Cinderella-Castles nicht nur das Innere des Disney-World-Schlosses, sondern auch eine Architektur, die auf das Innere eines anderen Schlosses, nämlich dem aus der Zeichentrickadaption des Cinderella-Stoffes aus dem Jahre 1950 verweist.

Man durchwandert somit drei Schichten einer Traumwelt, und löst sich damit immer weiter von der konsensuellen Realität, ohne diese jedoch zu verlieren. Der erste Schritt ist das Betreten der artifizielle Welt von Disneyland, niemand wird dessen künstlichen Charakter bezweifeln, diesen aber in einem Prozesse des *„willing suspension of disbelief"* seiner Realitätswahrnehmung angleichen. Die zweite Ebene stellt dann das artifizielle Märchenschloss dar. Das Schloss ist ein Prachtbeispiel für narrative Architektur. Es impliziert automatisch Erinnerungen an Märchen, Könige, Prinzessinen und Drachen. (Von denen dann auch in Disneyland Paris tatsächlich einer im Keller des Schlosses schlummert) Der dritte Schritt ist nun der verfeinertste: Die reale Möglichkeit, in diesem

Fantasy-Setting zu leben. (Und sei es nur für eine Nacht) Man selbst wird Bestandteil einer fantastischen Parallelwelt, deckt des Nächtens mit feinster Seide und überblickt aus den bleiverglasten Fenstern ein riesiges magisches Reich voller Achterbahnen, Roboter und Süßigkeiten.

Diese Technik der Realitätsvermischung entwickelt Disney gleichzeitig auch in die andere Richtung. Der Prototyp eines Roboter-Dinosauriers namens *„Lucky"* befand sich letztes Jahr auf den Strassen von Walt Dis-

Neuschwanstein

ney World in Einsatz. *„Lucky"* zieht einen Karren voller Blumen, und wird von einem Magier begleitet. Der Dinosaurier läuft und bewegt sich lebensecht und reagiert auf die Besucher. Er macht kleine Tricks und Mätzchen, klaut einen Luftballon und wird somit ein realer Akteur zwischen den Besuchern.

Dies ist sicherlich erst der Anfang der technologischen Vermischung von fiktiven und konsensuellen Welten, der wie ich finde, in seiner haptischen Erfahrbarkeit viel sexier als jeder Cyberspace und jedes Second Life ist. *See you!* in Disneyland.

Yours truely, Sherlock

Zur vertiefenden Lektüre empfehle ich wärmstens: Stephan Sepp, von „Ludwigland" nach „New Neuschwanstein", Institut für Kunstgeschichte, Stuttgart, 1998

Interview mit Jeff Pepper

Robert Venturi, Denise Scott Brown, Steven Izenour „Learning from Las Vegas". Robert Venturi arbeitete später sympatischer Weise mehrfach für den Disney-Konzern und entwarf z.B. das Bankgebäude in „Celebration", der „Idealstadt" der Disney-Company

http://www.disneyeverest.com
http://www.wdwnews.com/viewpressrelease.aspx?pressreleaseid=105079
http://en.wikipedia.org/wiki/suspension_of_disbelief
http://www.acidheaded.com/lucky

43 44

Laser Magazine. Double Spread. Number 02. September 2007.

andere Richtung. Der Prototyp eines Roboter-Dinosauriers namens „*Lucky*" befand sich letztes Jahr auf den Strassen von Walt Dis-

— *Times Ten*

Neuschwanstein————————— *Courier New*

```
------------------------
Zur vertiefenden Lektüre
„Ludwigland" nach „New N
Stuttgart, 1998
------------------------
Interview mit Jeff Peppe
```

Laser Magazine. Number 02. September 2007. Detail in actual size.

HUI HUI IS NOT JUST
FASHION HUI HUI
IS LIKE CLOSE FRIENDS
AND FAMILY
HUI HUI IS FLOWERED
TODAY AND CHECKERED
TOMORROW HUI HUI
IS COLOURS AND SHAPE,
HIM AND HER, STRONG,
WITH A TWIST OF MILK
SPRING, SUMMER, AUTUMN,
WINTER AND NEVER
AGAIN LIKE WINTER, AUTUMN,
SUMMER, SPRING. HUI HUI
MAKES VISIBLE WHAT FILLS THE
SPACE BETWEEN US. HER, HER AND ME
US IS HUI HUI

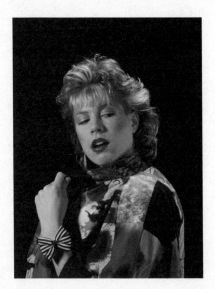

Hi Rozzetta, Jenny!
Interview by Michael Satter

Please tell us about yourself. Where do you come from?
Rozzetta is from Milan / Bologna / Firenze. I am from Stockholm, Sweden.

When did Italo Disco start for you personally? What was the catalyst? What influence did your friends have on it?
I never listened to it in the 80s when it happened. It probably plays a part in why I got so obsessed by it later on. I only remember Righieras *"Vamos a la playa"*. Around 1999 I was quite charmed by the electroscene that was happening then, and my then boyfriend played me some of his old records, Digital Emotion, Scotch and Hipnosis. I fell in love with the sound and the aesthetics and started to collect records and later became totally obsessed.

Is there any artist that had a big influence on you?
I was always more into the guys. They seemed to have a much better time than the silly girls. But I think Rozzetta is influenced by every female *"product"* artist out there. There are so many good ones in italo; Rose, Angie Care, Linda Jo Rizzo, Katy Gray... Big hair and bad dancemoves overload!!!

How did you get into DJing? Maybe you can tell us about the beginning of your career, your first experiences or about your first gig.
I think it was at my friend Joels club La La Land. I was totally oblivious, didn't even know what beatmixing was and I remember my hands were shaking so bad I couldn't handle the pickup. I wasn't very good, but I must have liked it since I continued to do it.

Is there an Italo scene with clubs in Stockholm? Do people get it? I mean, Italo Disco can be quite obscure and weird. How do people react who are not that familiar with this sound?
Nowadays you often hear DJs play some Italo in their sets, but it's mostly electro Italo that has become accepted. The reactions are a little divided, there is always some guy with tears in his eyes that

Laser Magazine. Double Spreads. Number 02. September 2007.

76

Written by Nessie White (Journalist)

Metal Magazine, Spain
(Albert Folch Studio)

When fashion maverick Daniel Sannwald was a kid, he dreamt of being a famous scientist.

That he became a photographer had a lot to do with his late father, who was an artist and in his short time gave Daniel the direction of photography.

But in some ways Daniel secretly still is a mad scientist working with utterly fictional technology to forward his schemes. Judging from Sannwald's work you'd except to find embalmed mutant creatures to be hidden in the cupboards of his photostudio or secret potion to be found there in glass jars. Yet if there one thing he wouldn't be caught dead in it's a lab coat. Daniel is not about being meticulous, you see.

True liberty for him lies in the right to make mistakes, as moving about and experimenting is always more interesting then being careful. In a society which is focused on the perfect image, he's trying to regain the sense and quality of mistakes and is not afraid of showing 'errors'. *"Keeping it real"* is what they call that on the streets.

Sannwald doesn't make choices between nature and technology, blending really raw animal stuff with high tech or clashing something organic with something computer generated. He seems somewhat torn between love and disgust for the digital age *"I hate these over-worked perfect images which are one result of the digital time. I love badly done digital things however: stuff with too much pixels, wrong colours and cheap Photoshop filters."* If he overworks, he makes clear to the viewer exactly what he did and how it came about. Apart from fragments of the digiculture his work carries echoes of pop art, film noir and German expressionism. From the latter he got his way of shifting chiaroscuro lighting and the convenient idea to paint light and shadow onto the scenery rather then to produce it. To create the right *'Stimmung'*. Sannwald mostly builds his 'haunted' sets himself. *'Tech Noir'* would be an apt term to describe his work for a number of reasons. Take for instance those monsters we mentioned earlier. Sannwald quite likes strange creatures, especially those from the old days. *"Where it's very clear that they're wearing a mask. Basically I'm a big fan of masks in general. In my work I often hide faces behind masks or burn faces out, cut faces out et cetera. I like disguise–*

HE IS ALLERGIC TO
THINGS THAT ARE
TOO SLICK, TOO CLEAN,
AND TOO PLASTIC.

the way people use masks in our daily life. In my pictures in a way I try to deprive people of their own identity."

It's often a case of recontextualising, he states. *"I sometimes take existing images from the past – like for example Dali's human skull – and recreate it in the context of fashion. I'm fond of semiotics, giving things a new place and a new meaning. Those who don't want to imitate anything produce nothing"*, is a motto by *Dali* that is tightly embraced by Sannwald, be it in a slight pop-art way. For Sannwald the art of today is all around us as he finds a great deal of inspiration in daily life. He estimates that about 80 percent of the time his brain is thinking about art and work, buzzing up new ideas for pictures. Sannwald's photos are refreshingly stylistic, bringing back a creativity and fun in the world of fashion photography. *"I think photography is a great tool to communicate moods. Why not make people laugh?"* he smiles. Sannwald himself is quite a happy and cheery fellow, indeed, leading a balanced and inspiring life in Antwerp where he did his master at the Royal Academy of Fine Arts. But never underestimate Sannwald's rebel yell. He's not cleaning up and calming down anytime soon. Daniel Sannwald photographs and lives solely on his own terms, following the road his own whirlwind of originality dictates. He always goes for carte blanche, no less. And that's the way he's conquering fashion magazines all over the globe.

HE IS ALWAYS SOME-
WHERE INBETWEEN
A PIRATE AND A
DREAMER.

Born in Germany, honours MA degree,
Royal Academy of Fine Arts Antwerp, Belgium.

He worked for magazines such as i-D,
Dazed and Confused, Hint, Tokion, Korean
Haper's Bazaar.

www.danielsannwald.com

67

68

Hui Hui Fashion
Nina Jan Beier
Marie Jan Lund
Anna Giertz
C. Sherlock Richter
Rozzetta
Szpilman Award
Tina Schott
Daniel Sannwald
Vier 5 ———————————————— *Times Ten Bold*

Laser Magazine. Backcover. Number 02. September 2007.

Laser Magazine features a very rational use of typefaces.
The mix of custom designed fonts as *Laser Regular* and *Laser Spray*, used on the cover, give the feature of exclusivity. The fonts chosen respond to functional criteria: *Times Ten* for its versatility of use in large and small bodies, and also aesthetic, *Gill Sans* is a good example of this quality.

*'Punk, black superheroes, tenacious
and willing and the Revolution'*

Lieschen

Editor / Director: **Judith-Anna Czech**, **Annika Janssen**, **Sabrina Merdzanovic,
Elena Schneider**, **Christian Schramm**, **Eva Strauch** and **Daniel Treufeld**
City / Country: **Dortmund / Germany**
Founded in: **2006**
Art Direction / Graphic Design: **Judith-Anna Czech**, **Annika Janssen,
Sabrina Merdzanovic**, **Elena Schneider**, **Christian Schramm**, **Eva Strauch** and
Daniel Treufeld
Collaborators: **the Students of the University of applied sciences, Dortmund.**
Dimensions: **215 x 335 mm**
Number of pages: **152**
Language: **German**
Periodicity: **annual**
Website: **www.radau-gestaltung.de**

CUSTOM
TYPE

HEADLINE
DESIGN

DESIGNER

TypoMag / *Lieschen*

79

Klebo 01

Dolly Roman

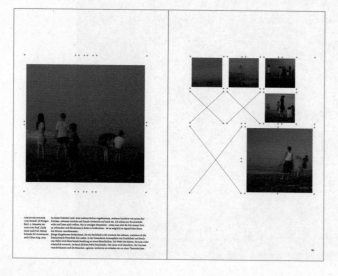

First of all, the cover shows the empty grid, which inside the magazine is used to show the works.

Lieschen magazine emerged as a platform where the students at the Dortmund University for Applied Sciences, in Germany, could place their latest creations on display. With the invaluable assistance of these students, *Lieschen* has become a publication which they themselves dare to define as a "bull in a china shop." We find the topic of tenacity and its name *Lieschen* in German meaning "Busy Lizzie" that is the diminutive of the name Elizabeth but also refers to "fleissiges lieschen" (worker Lieschen) which is a very tough, green plant. Apart from this topic, they have created some really tough superheroes like the Black Bars, who are always ready.

Without a doubt, the layout is the most important aspect within the magazine design. With this we can see the conceptual framework and it serves as a guide to the drama of the

Klebo 007

The headline typeface, *Klebo*, was created by the designers. The concept was to make a font that looked like as if it was made of duct tape. In this example the typefaced used is a *Klebo 004*.

Klebo 004

Klebo 001

-Shirts, die nicht nur von Medien-
bedeutungsschwanger aufge-
gl. Kleiner 2004), genannt werden.
Castro, Andreas Baader & Co.
schon zu »Posterboys der Revo-
Iisik) geworden. Undsoweiter
soweiter ...

scheint hierbei, dass noch vor
le Weltverbesserer bzw. Weltver-
ronistische und hoffnungslose
belächelt wurden. Wirklichkeits-

publication. The magazine content is entirely in the hands of the designers, taking their own decisions about contents to include and their aspect, highlighting design aspects such as punk, tenacious and willing black superheroes and the revolution.

Klebo, the typeface used in the titles, is their own creation. The concept was to create a font that looked as if it was made of duct tape. For the texts *Dolly* is the typesetting election created by Underware, an entertaining and interesting font, with a pleasant and not so mellow body. *Klebo* arises from the superheroes, The Black Bars, and with their rough strong faces convey the idea of guerrilla tactics and an underground movement.

The front cover is an empty space which displays the creations on an almost completely black background, making the magazine itself look like a black bar.

For the texts, *Dolly* is the typesetting election created by Underware, an entertaining and interesting font, with a pleasant and not so mellow body. Detail in actual size.

Talking about revolution today!?
Der lange und beharrliche Traum von der Revolution und Subversion der Verhältnisse, nicht zu vergessen der Mythos 1968, modern, spätestens seit dem Zusammenbruch des Staatssozialismus und dem Verschwinden von großen, revolutionären Sozialutopien oder wegweisenden Zukunftsbildern als konkreten Handlungsoptionen, auf dem Müllhaufen der Geschichte.

Der Medientheoretiker Rudolf Maresch (2004: 11ff.) deutet diese Entwicklung, mit Blick auf Europa, wie folgt: »Als die Mauer fiel, ein utopischer Megatraum zerbarst und seine Trümmer vor Ort studiert werden konnten, meinten Kommentatoren und Meinungsmacher, darin sogar das ›Ende des utopischen Zeitalters‹ [...] schlechthin zu erblicken. Die Zeit der großen Erzählungen sei vorbei, das utopische Denken habe ausgeträumt, die Geschichte sei am Ende, sie habe ihr Ziel – die globale Ausbreitung des Marktes – erreicht, von sozialphilosophischen Entwürfen habe man sich deshalb schleunigst zu trennen. So oder so ähnlich tönte es allerorten, vornehmlich von konservativer und liberaler Seite, während der Großteil der politischen Linken in eine bislang nie gekannte Sprach- und Hoffnungslosigkeit verfiel. [...] Die Gründe, warum Europa apathisch, leer und ausgebrannt wirkte, ohne Frische, Zuversicht und Unbeschwertheit; warum es im Zustand der Lähmung und großer Müdigkeit verharrt, liegen auf der Hand. Zwei blutige Weltkriege, Völkermord, Vertreibung und Gulags, die Erfahrung von Totalitarismus, Rassismus und der Wirkung von Massenvernichtungswaffen, haben Zweifel an der menschlichen Gestaltungskraft gesät und jede ›utopische Schwärmerei‹ abkühlen lassen.«
Ende neu? Andererseits werden diese Revolutionsphantasien und Sozialutopien kontinuierlich recycled, vor allem in der (Pop)Kulturindustrie, zum Beispiel als *Revolutionsmarketing, Radical Chic*, riskante Phantasie qua Buch- und CD-Kauf sowie Film- und Ausstellungsbesuch oder durch unterschiedlichste Spielarten des Differenzkapitalismus und *Self-fashioning*. Linke Kritik und rebellische Gesten sind in unseren Landen wieder hip: zum Beispiel in der Popmusik (*Wir sind Helden*), im Film (*Die fetten Jahren sind vorbei*) oder politisch (*Die Linke*). International wird zudem etwa die *angewandte Dissidenz* eines Michael Moore gefeiert oder die Theorie-Bestseller *Empire* und *Multitude* von Antonio Negri/Michael Hardt. Nicht zuletzt können in diesem Kontext die Haltungs- und Widerstandsmode, etwa in Form von *War is not the answer!-T-Shirts*, die nicht nur von Medienpersönlichkeiten bedeutungsschwanger aufgetragen werden (vgl. Kleiner 2004), genannt werden. *Che Guevara, Fidel Castro, Andreas Baader & Co.* sind auch längst schon zu »Posterboys der Revolution« (Robert Misik) geworden. Undsoweiter Undsoweiter Undsoweiter ...

Längst vergessen scheint hierbei, dass noch vor einigen Jahren alle Weltverbesserer bzw. Weltveränderer als anachronistische und hoffnungslose Retro-Aktivisten belächelt wurden. Wirklichkeitssinn bewiesen hingegen vermeintlich die, die auf Kapitalismus, freie Marktwirtschaft, Zukunftsoptimismus und die Feste der Erlebnisgesellschaft

setzten, sich also in der Wirklichkeit in ihrem *status quo* einrichteten. War dies noch signifikant für die *Generation Golf* (Illies 2001), das sind die zwischen 1965 und 1975 Geborenen, und ihr Verständnis von Politik, so nimmt heute *der Junge* seine Gitarre und singt wieder: *Hallo! Worum geht's? Ich bin dagegen!* Frei nach dem Motto: »Die Welt verändern, ohne die Macht zu übernehmen« (John Holloway). Und damit zu versuchen, inmitten des kritisierten Systems *temporäre autonome Zonen* zu schaffen, in denen dem Kapitalismus *in*, *mit* und *durch* ihn selbst, Einflusszonen abgerungen werden können.

Der österreichische Essayist Robert Misik (2005: 13ff.) liefert für diesen Trend folgende Erklärung: »Die neue linke Welle ist zunächst ein Symptom. Symptom einer Sehnsucht nach starken politischen Alternativen und nach einer unbestimmten ›Ernsthaftigkeit‹; eine Sehnsucht, die von der breiten Lawine kapitalistisch-kommerzieller Geistlosigkeit wohl selbst produziert wird. Hier kommt die Hoffnung auf eine ›Echtheit‹ - die Echtheit des erfüllten Lebens, wirklicher Gefühle, sinnvoller Tätigkeiten – zum Tragen, die natürlich sofort wieder unterlaufen wird. Denn wer wüsste besser als der Kapitalismuskritiker – und der Marktstratege –, dass mit jeder Sehnsucht ein Geschäft zu machen ist, also warum nicht auch mit dieser. Die Dissidenz wird zur Ware und produziert Bilder, die von Befreiung erzählen und irgendwie wie Werbung aussehen. […] Gewiss hat der Kapitalismus mit den Rebellen gut zu leben gelernt. Aber es sind doch auch diese rebellischen Impulse, die ihn verändern. Er hat die Einsprüche zu integrieren gelernt; das ist seine große Stärke. Aber, wer weiß, womöglich gibt es doch auch subversive Energien, denen der paradoxe Raum der herrschenden Ordnung nicht die Spitze zu nehmen vermag.«
Seit Ende der 1980er Jahre wird also einerseits immer wieder auf die Erschöpfung linker politischer Praxis und das Ende der Utopien bzw. *großen Erzählungen*, andererseits auf die Notwendigkeit zum Neuentwurf und dessen konkrete Möglichkeiten hingewiesen. Dieser Neuentwurf wird gegenwärtig weniger als ein Kampf der Ideologien konzipiert, sondern vielmehr als ein Gestalten von *anderen Räumen, Heterotopien*, in denen neue Ausdrucksformen der Kritik und Produktion sowie zeitgemäße Agitations- und alternative Lebensformen entworfen werden.
Eine Widerstandskultur, die sich in diesem Kontext entwickelt hat, ist die *Kommunikationsguerilla*. Mehr als ein kurzer Rundgang durch die Diskursgalerie und Praxisformen dieser aktuellen Widerstandskultur, können im Folgenden nicht geleistet werden (vgl. hierzu ausführlich Kleiner 2005; Kleiner/Fluck/Winter/Nieland 2007).

KOMMUNIKATIONSGUERILLA

Die Ansätze der *Kommunikationsguerilla* können allgemein als Versuch der aktionsbasierten Störung alltäglicher Medienkommunikationen und Medieninszenierungen bzw. gesellschaftlicher Kommunikationsprozesse sowie als elektronischer Widerstand, u.a. im Hinblick auf das Internet als Aktionsmedium, gegen gesellschaftliche und mediale Hegemonie verstanden werden (vgl. autonome a.f.r.i.k.a.-gruppe/Luther Blissett/Sonja Brünzels 2001; Kleiner 2005; Kleiner 2006). Kritik kann aus dieser Perspektive nicht allein bzw. nur sehr eingeschränkt diskursiv erfolgreich sein, sondern muss primär in eine Praxis überführt werden. Diese soll die unterstellten *Aporien, Widersprüche* und *Repressionsmechanismen* der Medienkommunikationen und Medieninszenierungen sowie gesellschaftlicher Kommunikationen durch spezielle Methoden und Praxen anschaulich machen. Hierdurch soll *eine* Gesellschafts- und Medienkritik kritisiert werden, die rein diskursiv operiert und sich in selbstreferentiellen Diskussionszusammenhängen erschöpft, ohne das *Gros* der Mediennutzer und Bürger zu erreichen. Diese Form der Gesellschafts- und Medienkritik ist aus der Perspektive der *Kommunikationsguerilla* nicht nachhaltig und kann den Medienprozess und die Medienrezeption sowie gesellschaftliche Kommunikationsprozesse, wenn überhaupt, nur sehr fragmentarisch beeinflussen. Hiermit ist ein Hauptproblem der Gesellschafts- und Medienkritik benannt, nämlich die Frage nach der Vermittlung kritischer Inhalte. Weder bei einer

Lieschen. Double Spread.

'Honest, passionate and unmerciful'

Little White Lies

Editor / Director: **Matt Bochenski**
City / Country: **London / United Kingdom**
Founded in: **2004**
Art Direction / Graphic Design: **Paul Willoughby**
Illustration: **Michael Gillette**, **Siggi Eggertsson**, **Vania Zouravliov**, **Emily Alston**, **Jon Boam**, **Stevie Gee**, **Amy Brown** and **Andy Miller**
Photography: **Sam Christmas** and **Spencer Murphy**
Dimensions: **200 x 245 mm**
Number of pages: **122**
Language: **English**
Periodicity: **bimonthly**
Website: **www.littlewhitelies.co.uk**

Little White Lies. Cover. Number 24. July / August 2009.

9 771745 916017

ISSUE 24 JULY/AUGUST 2009 £3.75

LITTLE WHITE LIES

Truth & Movies

Vincent Cassel in MESRINE

Little White Lies. Double Spread. Number 18. "The Man On Wire".

Little White Lies. Double Spread. Number 16. "Persépolis". Each journal is dedicated to a film and the graphic and typographic style fits this film in particular, hence the typefaces used are almost limitless.

Little White Lies. Double Spread. Number 19. "Gomorra".

Honest, passionate and unmerciful. That is the definition of *Little White Lies*, a London magazine created in 2004 by Danny Miller. The magazine content is like "toast with foie gras and onion marmalade," i.e., an explosive mixture that produces a multitude of sensations and flavours. The publication title came from the lyrics of a song and soon became a mirror and a window opening onto culture. It is a bold, audacious passionate magazine inspired by the movies and everything that moves around them.

Little White Lies has opted for a continuous change, with a fresh attractive appeal which leads them to create something beautiful in the realisation of each issue. The main intention in this search for beauty is the use of different inks in each issue, as if they had a white canvas for the creation of a new design.

Substance and style surround the fonts used, **Knockout**, **Akzidenz Grotesk** and **Cooper**, although, the magazine is going through a constant evolution and change in each issue. Each magazine is dedicated to a film and the graphic and typographic style fits this particular film, hence the fonts used are almost endless. A tailor made typeface accentuates the uniqueness of the project and gives strength to the magazine.

Little White Lies. Double Spread. Number 22. "The Ché".

Love

Editor-in-Chief: **Katie Grand**
Country: **United Kingdom**
Founded in: **2009**
Creative Direction: **Lee Swillingham** and **Stuart Spalding (www.suburbia-media.com)**
Design: **Stafania Tomasello**
Dimensions: **232 x 300 mm**
Number of pages: **Variable**
Language: **English**
Periodicity: **Biannual**
Website: **www.thelovemagazine.co.uk**

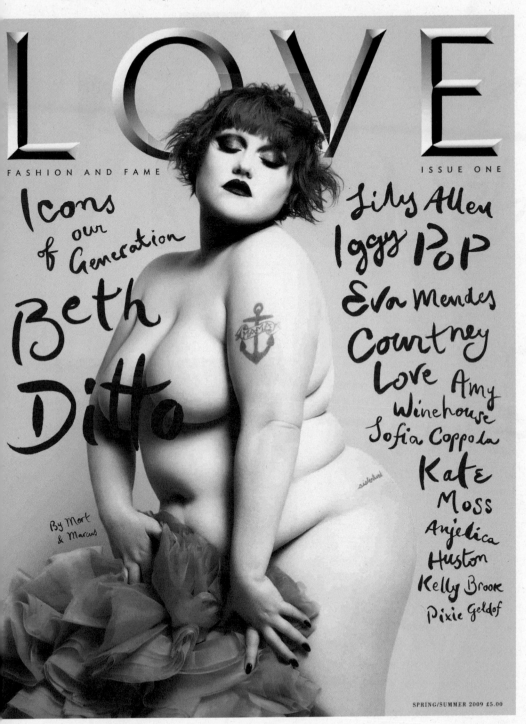

LOVE

FASHION AND FAME

ISSUE ONE

Icons of our Generation

Beth Ditto

By Mert & Marcus

Lily Allen
Iggy Pop
Eva Mendes
Courtney Love Amy Winehouse
Sofia Coppola
Kate Moss
Anjelica Huston
Kelly Brook
Pixie Geldof

SPRING/SUMMER 2009 £5.00

BY HAND

CLASSIC

LOGO

HEADLINE
DESIGN

TypoMag / *Love*

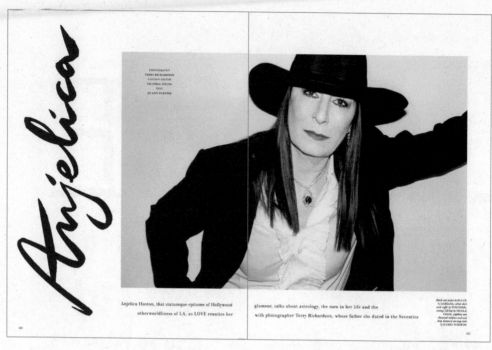

PHOTOGRAPHY
TERRY RICHARDSON
FASHION EDITOR
VICTORIA YOUNG
TEXT
JO-ANN FURNISS

Anjelica Huston, that statuesque epitome of Hollywood
otherworldliness of LA, as LOVE reunites her

glamour, talks about astrology, the men in her life and the
with photographer Terry Richardson, whose father she dated in the Seventies

Black suit jacket by DOLCE
& GABBANA, white shirt
with ruffle by TOM FORD,
vintage hat by NICOLE
FARHI, sapphire and
diamond necklace and real
drop diamond earrings both
by HARRY WINSTON

Love. Double Spread. Number 1. Spring-Summer 2009. The layouts and cover incorporate hand made graphics and typography. The idea was to recall fashion magazines of the 1930s and 40s.

Fashion's hardest-working hedonist Pam Hogg
is back rocking a new label, Hogg Couture

Pam wears her
own by HOGG
COUTURE

Fashion designer Pam Hogg is not really a fashion designer. Or so she claims. 'Well, I am a designer. I am a singer. But I'm not just one of those things,' she says, talking 30 to the dozen because the ideas for her next collection have started bubbling up in her head and are ready to burst into life on her sewing machine. 'Actually, no, I'm not a designer in inverted commas because I don't design in any formal way. It's totally erratic, what I do, absolutely unortherdox.' In Pam's studio there are no mood boards ('Mood board? What the fuck is that?'), no sketches ('I'm a fine artist, but I never draw'), no draping chiffon on a mannequin ('I make every piece on my own body') and no design teart: just Pam sitting in the middle of the floor checking pieces of fabric around, with all clothing samples ready by her own fair hand.

When she first started making clothes, in the early Eighties, it was because she had nothing to wear. 'I studied fine art and printed textiles and had no intention of doing fashion at all. It just happened. People kept asking me, "Where did you get that? Will you make me one?" Before she knew it, Pam was selling her clothes from a stall in trendy Eighties fashion emporium Hyper Hyper, and then from her own shop in Soho. By the end of the decade, i-D had deemed her one of the two most important designers in Britain, along with Vivienne Westwood, and in 1991 she was even a guest on BBC One's prime-time chat show Wogan – tipsy on champagne and sitting on Terry's lap.

And then suddenly, later that year, 'I gave it up as early as I came into it.' She was on tour with her boyfriend and his band Pig Face when 'they dragged me on stage in Nashville. And I was like, oh my god, I'm doing this and giving up fashion!' This wasn't her first time singing on stage – she'd been in a punk band in the late Seventies and an acid house collective in the late Eighties.

But after her Nashville epiphany she set up a new band, Doll, when Debbie Harry asked her to join her on tour in 1993.

And then, after a decade of playing live and partying, Pam fell back into fashion again. An invitation to contribute pieces from her archive to an exhibition in Bilbao in 2005 saw a flurry of new interest in her old clothes. 'A couple of friends said Pam, this is ridiculous, you should be doing clothes again. And I had got the itch to go back to it.' They sponsored a studio for her, kickstarting a couple of small collections as Pam found her feet as a designer once more. The collection that followed was not only bought by Browns, it was chosen to fill all four windows of the South Molton Street store for Halloween last year. Now she finds herself inundated with offers from producers, set designers and models who grew up loving Pam Hogg and want to help her get her new label, Hogg Couture, into full swing.

Pam's take on fashion is as intuitive, chaotic and personal as it ever was. Still a rampant party animal, her collections remain extensions of the clothes she makes to dress herself for a big night out. 'But this time around I want to have great production. Last time I was selling all over the world, but nearly every piece of every item was cut in my studio. Liberty would call and say, "Other designers ring us up to ask, do you want some more? We have to ring you and ask, where's our order?" I was always struggling to get stuff out.'

Once such practicalities are taken care of, she'll be free to focus on designing. 'I have to work in chaos, that's where it all happens for me. But there's part of my life that needs to be organised, and that is the business side. Of course, the worst time to come back into this business is in a recession. It worries me, but the panic feeds the creativity. My life has never been easy. Easy is boring!'

PHOTOGRAPHY
DAVID SIMS
FASHION EDITOR
JOE McKENNA
TEXT
MURRAY HEALY

Love. Double Spread. Number 1. Spring-Summer 2009. The editor wanted to do something different with *Love*, and create something more modern and "real" than the average style magazine. The distinction is perhaps more subtle than she would have liked. The use of lively brush lettering makes it more personal and edgy.

ace – though obviously she's that too!

WHO WAS YOUR FIRST LOVE? The first time I fell in love I was at Disneyland. I was about nine years old, waiting in line for Mr Toad's Wild Ride and I saw

Love. Double Spread. Number 1. Spring-Summer 09. Detail in actual size.

With the title of *Love*, from the Condé Nast group and designed by Suburbia, Lee Swillingham and Stuart Spalding surprise us with a magazine which has caught everybody's attention in the lively world of design; a publication which hallmark is fashion and fame. According to its creators, a magazine is something beautiful, which in the case of *Love* may be "an incredible pair of shoes." Its story began with *Pop* magazine, a publication where Lee Swillingham and Stuart Spalding worked and which they left with the intention of creating a new project for Conde Nast. In the words of Swillingham, *Love* would be like *Pop*'s older sister, an evolution of the concept of high fashion and lifestyle magazine, with higher spending and creative possibilities.

When all the pieces of this new project finally fitted together, all that was needed was the name of the magazine. But Lee finally had an inspiration and thought that *Love* gave a message of hope and encouragement in the midst of a global recession.

Love is redesigned in each issue and many of its graphics are created manually and, of course, with lots of love, giving a custom made feeling which is so appreciated. This approach supports their own creation philosophy which is contrary to those design magazines that have opted for a "mass production of typefaces" approach, comparable, in their own words, to a "sausage factory."

In the design of the header they wanted to get away from *Pop*, which is more a product of trends, and create something classical. The logo uses the Cimiez font, originally designed by Gert Wiescher and based on a classic font traditional among the XIX century French engravers, with sharp corners and a touch of Art Deco style. The designers redrew it to suit the header, which will vary in the different numbers of *Love*.

We have eight possible covers, available in London and Paris, with the recently published number three. The eight different covers are available to view at Suburbia's website *www.suburbia-media.com.*

True to its name, *Love*, in its intrinsic relationship with the world of fashion, has created a limited edition of t-shirts with proceeds to go to Haiti.

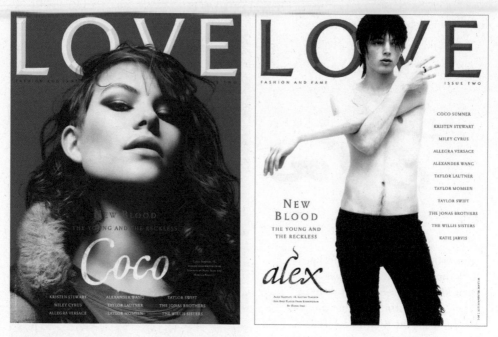

Love. Covers. Number 02. Lee Swillingham and Stuart Spalding combined hand-made textures with digital manipulated fonts, to achieve an elegant and gothic look.

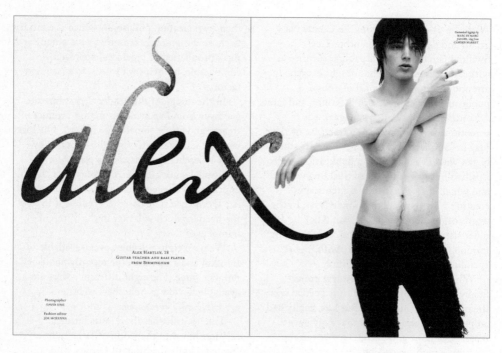

Love. Double Spread. Number 02. A fashion story opening spread. The type playfully responds to the image.

Eclectic

IN OUR HUNT FOR NEW BLOOD, WE DISPATCHED A SPECIALIST TEAM – including our Celebrity Editor Greg Krelenstein, our Senior Fashion Editor at Large Francesca Burns, legendary photographer Bruce Weber and New York designer Alexander Wang – to scour the Earth, from Merseyside to the Everglades. Our mission? To discover UNIQUE TALENTS UNDER THE AGE OF 21. It didn't matter if the precise nature of that talent had yet to define itself, or if the individuals concerned didn't know what they wanted to be when they grew up. All the better, that undefinedness, that openness to possibility, was exactly >

< what we were looking for. We wanted people caught in that moment of freedom and chaos when they have outgrown 24-hour parental supervision but are still gloriously innocent of the mundane responsibilities of adulthood; awake to their own potential but not yet a confirmed success. Above all, they had to be true to themselves in a way that marked them out. Driven by an overwhelming need to be their own person, at all times and in a way that makes them different, that makes their lives difficult even, never satisfied with settling for the easy route of doing what all their friends are doing. Because if you know you have what it takes TO BECOME SOMEBODY, why bother with being just anybody? And we found them: a mixed bunch to say the least. We can't define what it is that unites the young people in the following pages. And even if we could, we wouldn't want to: to do so would be a disservice to what makes them so unique. Suffice to say that they all have that spark, and we think

Youth — *they're all amazing.*

Love. Double Spread. Number 2. The gothic handwriting was often used without images to create graphic pauses throughout the issue.

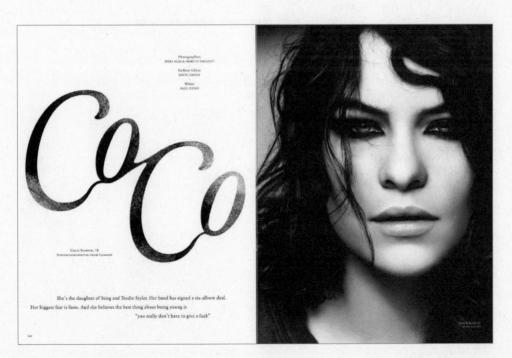

Photographers:
MERT ALAS & MARCUS PIGGOTT

Fashion Editor:
KATIE GRAND

Writer:
PAUL FLYNN

Coco

COCO SUMNER, 18
SINGER/SONGWRITER FROM LONDON

She's the daughter of Sting and Trudie Styler. Her band has signed a six-album deal. Her biggest fear is fame. And she believes the best thing about being young is "you really don't have to give a fuck"

Love. Double Spread. Number 2. Opening spread of the cover story.

Mark

Editor / Director: **Robert Thiemann**
City / Country: **The Netherlands**
Founded in: **2005**
Art Direction / Graphic Design: **Mainstudio (Edwin van Gelder)**
Dimensions: **230 x 297 mm**
Number of pages: **224**
Language: **English**
Periodicity: **bimonthly**
Website: **www.mark-magazine.com**

MARK

MARK №21
AUGUST . SEPTEMBER 09

WINNER GOLDEN CUBE
ART DIRECTORS CLUB
NEW YORK 2009
ADCAWARDS.ORG

—— ANOTHER ARCHITECTURE ——

MADE IN GENEVA — **GO HASEGAWA & ASSOCIATES** TOKYO — **DOMINIQUE PERRAULT ARCHITECTURE** MADRID — **JAN DE VYLDER ARCHITECTS** GHENT
ROBERT STONE DESIGN JOSHUA TREE — **URBAN REGENERATION IN COLOMBIA** — **RONAN-JIM SÉVELLEC** CHAVILLE — **MAMOSTUDIO** JAKARTA — **DRMM**
SUFFOLK — **MASSIMILIANO FUKSAS** FOLIGNO — **LETTER FROM AHMEDABAD** — **DENNIS SHARP** HERTFORD — **PHILIP BEESLEY** WATERLOO

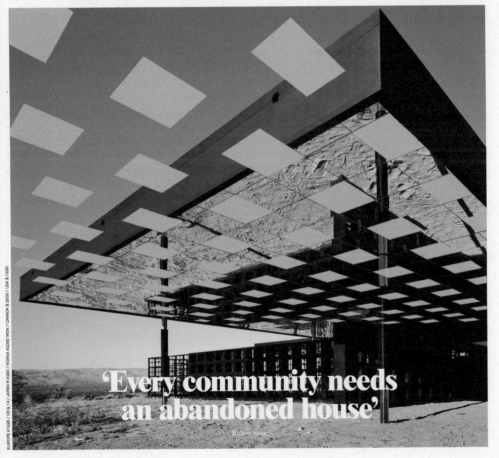

'Every community needs
an abandoned house'

Robert Stone

Mark is a magazine created, run by and for lovers of architecture. It gives us a marked radical international perspective, visually orientated and determined to escape academicism but without nearing superficiality. Its creators admit their passion and adoration for magazines, the touch of the paper, the smell, the excellent quality of the images, and for the stories. That is why they could think of no better place to find this wealth of experience. Mark gives us plenty of information and sensual experiences in the six issues that are published annually.

The origin of the name of the magazine, Mark, comes from the search for exceptional buildings; structures that make readers marvel and feel inspired. In many cases we are talking about buildings that have left their "mark"; apart from having this meaning, another word "arch", the first letters that appear in the word "architecture," is included in the word "mark." But there is another reason and that is because Mark is also a name and this made them think that this could help them start a more personal relationship with readers. This idea is used in the magazine, in an article that appears in every issue called "Dear Mark," where a writer offers a personal letter about the architecture of a certain city.

Given that the majority of their readers are spectators, they think that the images are of paramount importance for their project. The text, typography and layout take the rest of their energy but the high quality images are the point to highlight. Although the editors are responsible, the designer has a lot of freedom selecting and arranging images and given that Mark is a visually oriented magazine, we could say that the designer decides much of the magazine content. All the fonts used have been updated and are versions of known originals with an attractive design. *Neutraface Light* and *Bold, Neutra Display Thin, Times LT Extra Bold, Times Ten Roman* and *Bold,* and *Berthold Akzidenz Light* and *Bold* are some of the most common fonts. The *Neutraface* of House Industries typeface was designed from the font that the architect Richard Neutra used in signposting his buildings in the 1950s. While *Neutraface* is a soft open sans serif, *Times Ten Roman* is more blatant and condensed. However, the two are warm and human. The choice of letterpress is affected by a question of contrasts, upper and lowercase, bold and clear, sans serif and serif. The use of contrasts in typography gives the magazine a structure and endows it with poetry.

In its four-year history, Mark has changed considerably, and the typography is one of the fields in which there have been more changes. The first three issues had a different a paper and size. A hard psychedelic typography stood out that interfered with the images and resulted in a work of art, but not for an architecture magazine. Even though they are proud of those first issues they were not well accepted in the market, so they decided to make a drastic change in the whole magazine, something they did with great success. The following fifteen issues used original types of their own creation always based on the same fonts but changing in each issue. In issue eighteen another substantial change was made, making it more serious, more balanced and consistent. This earned them international recognition which materialised in them being given an award by the New York Art Directors Club.

Mark is a source of information of a marked personal style, combining the visual exaltation of its contents with a marked human character.

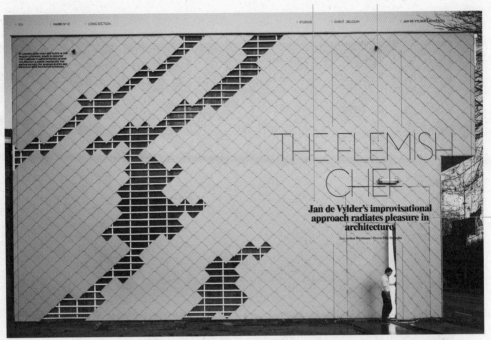

Mark. Double Spread. Number 21. September 2009. The typeface used in the headlines is *Neutraface*, by House Industries designed from the original that Richard Neutra used for the signage of his buildings in the fifties. It is no wonder that Neutra specified lettering was open and unobtrusive, warm and with human feel, the same characteristics which typified his progressive architecture.

Mark. Double Spread. Number 21. September 2009.

MADE IN
GO HASEGAWA &
ASSOCIATES

.6°

Mark. Double Spread. Number 21. September 2009.

Monocle

Editor / Director: **Andrew Tuck** and **Tyler Brûlé**
City / Country: **London / United Kingdom**
Founded in: **2006 (launched in 2007)**
Creative Director: **Richard Spencer Powell**
Dimensions: **200 x 265 mm**
Number of pages: **200+**
Language: **English**
Periodicity: **10 times a year**
Website: **www.monocle.com**

IS THAT A ROCKET UNDER YOUR KIMONO? BLASTING OFF FROM JAPAN'S VINTAGE SPACE CENTRE

MONOCLE

A BRIEFING ON GLOBAL AFFAIRS, BUSINESS, CULTURE & DESIGN

issue 28 . volume 03
NOVEMBER 09

(A) **AFFAIRS** Europe's last African colonial outpost

(B) **BUSINESS** Sail of the century: time to buy a boat?

(C) **CULTURE** How to build your own band in a download world

(D) **DESIGN** A perfectly crafted tour of Swedish classics

(E) **EDITS** A nice Naples neighbourhood and the world's toastiest blankets

EXPO Is Tanegashima the next Cape Canaveral?

Should you or shouldn't you?
Go and launch your own business

From Kamchatka to Gothenburg to Seattle – Monocle reveals a **HOST OF OPPORTUNITIES** *for anyone who's been thinking of packing up and jacking in corporate life*

GOT A BRIGHT BUSINESS IDEA?

INTRODUCING THE MONOCLE GUIDE TO SMALL BUSINESS
A new 36-page supplement

WHY THE CLIMATE HAS NEVER BEEN BETTER TO LAUNCH YOUR OWN COMPANY
page 007

TEN INSPIRATIONAL STORIES FROM TINY ENTERPRISES
page 010

HOW TO SET UP SHOP
page 018

FINDING THE FUNDS: HOW TO SECURE INVESTMENT FOR YOUR NEW START-UP
page 021

THE BEST COMMUNITIES TO SUPPORT A NEW VENTURE
page 022

BUILD A HANDSOME OFFICE
page 028

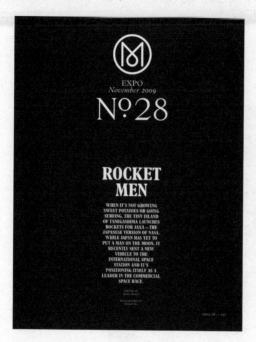

With their headquarters in London and delegations in Tokyo, Zurich and New York, *Monocle* is published ten times a year and is continually updated on *www.monocle.com*. Launched in February 2007, *Monocle* reports on international topics of interest related to the business world, culture and design in an attempt to give us a serious magazine with a certain approach to the old journalistic values. We find texts that are generous in content, worked on by special envoy photographers and writers who live the news in situ and invest in local talents. *Monocle* tries to innovate in printing and go beyond usual news stand expectations whenever possible. Once the foundations or principles are settled, the major creative decisions emerge naturally.

Monocle. Interior Page. Number 28. November 2009.

Helvetica Plantin

Monocle. Double Spread. Number 28. November 2009.

The design has been chosen to last and not to be continually reinvented. Ken Leung, the artistic director gives us a wide and varied material with a simple variation in styles from the two types chosen. And it works wonderfully. Although it has been labelled as elitist, *Monocle* is a pleasure to read and achieves a pleasant sort of union between texts and a sophisticated design on its pages. Its typefaces are *Plantin* and *Helvetica*. No other appears on its pages. *Plantin* was their first option as they saw it as a type with more character than most serif, it has more charm, holds the ink well and is easily read and not at all rigid. It is a font with some numbers and a very beautiful old italic letter, especially the lower case "v," one of their favourites. In their opinion, *Plantin* has that special quality which raises it from the category of a simple word to convert it into a logo. *Helvetica* makes a perfect partner with *Plantin* because it brings a touch of modernity; both fit well together and do not clash. *Helvetica* is a good neutral model and *Monocle* is used mainly in small bodies of text in such a way that the page has balance and a hierarchy that works.

Even so, they underline that fact that the star of the magazine is not the typography. In an attempt to report on matters of worldwide interest regarding business, culture and design, words and images should be sufficient to tell the story; they should be the main focus and not the special treatment given to typography. *Monocle* tries to reduce it to a simple straightforward design. The nature of the magazine content calls the shots and worrying excessively about a typeface is considered to be totally unnecessary when a war conflict is being talked about. They expect the reader to be sufficiently interested in the story to not need to look at anything else.

In this case the font should simply be elegant and readable. Of course, creativity is always present within these criteria and the aesthetic character of the typography should never be forgotten.

The *Monocle* philosophy is that, if you create something to last for a long time, it should have a long lasting aspect, giving it foundation and security, something that does not need to be reinvented every six months.

Plantin Light *Italic*

Plantin Regular *Italic*

Plantin Semibold *Italic*

Plantin Bold *Italic*

Helvetica Roman

Helvetica Bold

HOW TO
BE A BA
IN 2010
—*Global*

WRITERS
Robert Bound &
Jonathan Openshaw

ILLUSTRATOR
Satoshi Hashimoto

Preface
Rock stars are now essenti
CEOs of their own small (ar
big businesses). Learn how
harness patrons, sponsorsh
and the digital revolution, a
you could soon be selling o
without selling out.

The word "industry" is u
tainment than it was five
music biz has entered a pr
where artisans are weavir
smaller surroundings
smaller merchants. The

Monocle. Interior page. Number 28. November 2009.
Detail of Helvetica and Plantin in actual size.

REPORT
Small business nation

SMALL IS BEAUTIFUL
—*Global*

Preface
In Germany, small- and medium-sized firms make up the backbone of the economy, while elsewhere steps are being taken to ease the start-up process. But down on the Med there's a different problem: how to keep it in the family.

WRITER
Christoph Koch

ILLUSTRATOR
Always With Honor

Even in these turbulent times, Europe is a powerhouse of small companies: the vast majority of businesses in the EU are small- and medium-sized enterprises (according to the EU an SME has fewer than 250 employees) and they employ two thirds of the private, non-financial sector workforce.

Germany may not have the deep-rooted family culture or the agricultural traditions that make small businesses last generations in southern European countries. But it has made itself the small business nation everyone can learn something from. Germany's small business culture (70 per cent of the workforce work for an SME) is a result of history. A big part of the "economic miracle" after the Second World War came from people who started little businesses with almost nothing. A second boom came after reunification in 1990 and gave people a new wave of courage and inspiration. Germany often ranks top in terms of government aid and support for SMEs.

But what does the situation look like today? What kind of future can small businesses everywhere hope for?

Today, Germans are timid about starting their own company, says Frank Wallau, executive director of the Bonn-based Institut für Mittelstandsforschung. "When we do surveys we mostly hear it's the fear of failure that keeps people from

01 Old heads
USA
Babyboomers in the US are more likely to start a tech business than 25-year-olds. And more people aged 55+ are starting new businesses than under-34s.

02 Lone stars
USA
The number of one-man-bands in America is constantly rising. It is expected to increase by between 4 and 6 per cent in 2009.

doing it – in Anglo-American countries there is much less of this fear, because failure has less of a stigma."

Countries with a strong tradition of the small family business, such as Greece, Italy and Portugal, are facing different problems. Their younger generations are increasingly tempted to abandon the family business in search of broader horizons with larger companies.

The EU hopes to cut the bureaucracy with a directive which says that by the end of the year governments must provide a single contact point for all departments that are involved in starting a business.

Whatever governments do may not be enough, though. Unless banks worldwide get braver with their loans to help little people, some of the creativity effervescing out of the crisis may fizzle. — (M)

03 **Mighty in Blighty**
UK

In Britain, there are 4.7 million small businesses and these firms contribute more than 50 per cent of the UK turnover. Around 500,000 new small businesses are created every year.

04 **C'est facile**
France

France is cutting red tape to encourage start-ups. By the end of this year, the government says 500,000 new small businesses will have been launched compared to 328,000 in 2008 and 321,000 in 2007.

05 **Rule of two thirds**
Germany

Companies with up to nine employees make up 93 per cent of Germany's 1.6 million enterprises. Small- and medium-sized businesses employ over two thirds of the workforce.

06 **Go your own way**
The Med

Greece (35.9 per cent), Italy and Portugal have the highest rates of self-employment in the developed world. Luxembourg (6.1 per cent), the US and Norway have the lowest.

07 **Long legacy**
Japan

The family business that lasted for longer than any other is believed to be the Japanese temple-builder Kongo Gumi, founded in 578. It was sold in 2007 to a larger Japanese construction firm.

08 **Three-day start-up**
Rwanda

Rwanda has carried out more reforms than any other country in the past few years to make it easier to do business there. Entrepreneurs can now start a business in Rwanda in three days.

09 **Easy does it**
Singapore

This is the easiest place to do business, followed by New Zealand and Hong Kong, according to a World Bank ranking of 183 countries. Venezuela is the only non-African country in the bottom 10.

10 **Family value**
Global

Family businesses – large and small – account for more than 75 per cent of businesses in most economies. In the US, about 80 per cent of firms are family-run. In the UK, it's 76 per cent.

ISSUE 28 — 039

Monocle. Interior page. Number 28. November 2009. Infographics is one of many highlights of *Monocle*.

"A good Spanish omelette"

Editor: **Ipsum Planet**
Directors: **Javier Abio**, **Rubén Manrique** and **Ramón Fano**
City / Country: **Madrid / Spain**
Founded in: **1995**
Art Direction / Graphic Design: **Ipsum Planet**
Dimensions: **215 x 275 mm**
Number of pages: **144**
Language: **Spanish**
Periodicity: **monthly**
Website: **www.neo2.es**
www.ipsumplanet.com

Neo2. Cover. Number 90. February 2010.
With this issue they celebrate its 15th Anniversary and initiate a new stage which claim is "I'M INTO CREATIVITY"

CLASSIC

CUSTOM
TYPE

LOGO

HEADLINE
DESIGN

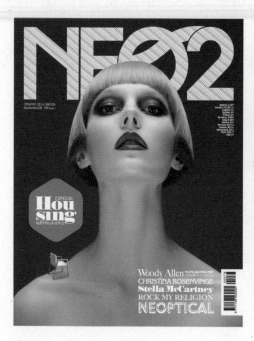

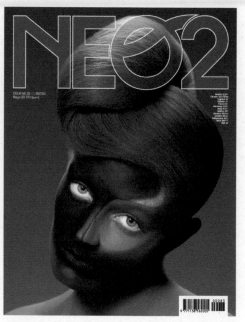

Neo2. Cover. Number 78. November 2008.　　*Neo2*. Cover. Number 83. May 2009.

All those outstanding creative trends in the field of fashion, furniture, art or gastronomy are subjects worth the attention of *Neo2*. With its headquarters in Madrid, for its creators, taking a look at their magazine is an experience comparable to eating a good Spanish omelette. Such a gastronomic comparison refers to the good sensations that *Neo2* gives us at a good price and being not only professional but also a free time source of inspiration. The *Neo2* story dates back to 1994, when a group of three friends with no experience in the publishing world, set up a creative studio called "Ipsum Planet" where weekends were devoted to creating a fanzine at a time when neither alternative press nor fashion magazines were even mentioned in Spain. At that time, *Neo2* was called Neomania, printed in 2 inks, which would vary from issue to issue, in a slightly larger format than A5 (which led them, as you may imagine, to a great dominance of duotones). Eventually, it became a real magazine. Little by little and reinvesting, they moved on from duotones to a four colour process. They left the cheaper reduced original A5 format, for another bigger but also unique one. They went on from publishing one issue a year to ten and gradually grew from 1,000 numbers a year to today's 70,000, achieving not only an international distribution in the major world capitals, but also a special edition for the Portuguese market, *Neo2* Portugal. After fifteen years and given the times we live in, where some projects are over in a blink of an eye, it is a feat to keep working with the same enthusiasm and stay in a market where *Neo2* has found its place.

In the beginning, *Neo2*'s graphic design took precedence over content, but eventually they realised that one thing doesn't make sense without the other. It may seem logical to take a lot of care in design and layout in annual publications where you can spend a lot of time on all kinds of details but where information is not current. In a monthly magazine surprise is of vital importance, so the freshness of content to be found in *Neo2* is an element that requires attention and is considered to be just as important as graphic design; there is a good communication and harmony between design and content. Those who write and edit an article must always ensure that the article will be visually powerful. This is achieved in *Neo2* through give and take on both sides and by good communication between editor and designer. All elements, typography, layout and photography are on the same level, but the dynamism of the magazine lies with the

photography, where there are changes in each issue, but typography and layout have guidelines which are normally defined each year.

This balance between basic aspects like content and graphic design is achieved with small details that prevent the magazine from declining in functions or becoming boring. In this way they introduce innovations that can be seen in some issues, like the composition of three columns in blocks of general text where one of the columns is smaller. This gives a different aspect to the structure of the classic layout used today. Another of their innovations is their "typographical casting" where they try to choose fonts which are not widely used and make them fashionable. Although *Neo2* is not currently using any tailored typeface, what it does is provoke other designers to generate typefaces which are given away in the magazine and later via its blog.

Their range of typefaces forms the different sections of the magazine. The selection is made following the basic principle in the design: the mixture of function and form. An element like the typography has allowed them to solve small problems that they have come across. The first

POR: RUBÉN MANRIQUE, RAMÓN FAN

están jugueteando con un dor de partículas, el Gran Hadrones se llama, con el desentrañar el origen del eando el famoso big bang e unos 13.700 millones de que el LHC (las siglas del en inglés) intentará hacer ar dos haces de hadrones atómicas) a una velocidad de la luz. "La máquina de an llamado algunos viene a de polémica, ya que hay ue consideran que el LHC gujero negro que pondría

Neo2. Detail in actual size.

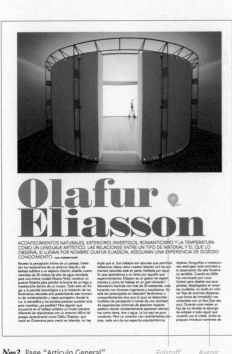

Olafur Eliasson

ACONTECIMIENTOS NATURALES, EXTERIORES INVERTIDOS, ROMANTICISMO Y LA TEMPERATURA COMO UN LENGUAJE ARTÍSTICO. LAS RELACIONES ENTRE UN TIPO DE MATERIAL Y EL QUE LO OBSERVA, SI LLEVAN POR NOMBRE OLAFUR ELIASSON, ASEGURAN UNA EXPERIENCIA DE GOZOSO CONOCIMIENTO.

Neo2. Page "Artículo General" *Falstaff* *Avenir*

Rubén Vega
COLABORADOR DEL MES

Falstaff *Avenir* *Neo2*. Page "Fijos"

content pages are called "Adeneos" and are always faced by pages with advertising. Each Adeneo is a mini article where sometimes the space becomes a problem to be taken into account, as there may be various photos on the one hand and a large piece of text on the other. *Big Caslon* was chosen for headers on these first pages, as it works well in small bodies. It is discrete and doesn't compete with advertising pages. A condensed type was chosen for the body text, resulting in *Din* as the ideal typeface because it is condensed and would allow more text input. If we move on to the general body of the magazine we then find *Avenir*. The existent *Helvetica* and *Futura* dichotomy over the last decades have caused a confrontation between their hard-core supporters and critics. *Neo2* has been able to recognise a font that mixes *Helvetica* and *Futura* keeping the best of both and that works well as body text. *Avenir* has an extensive family with interesting varieties of thickness and italic options for this part.

Neo2 headlines have a section called "Explosion" where we can find a collection of images on this subject. These enable the use of the rarer fonts, with a more complicated reading. In this case, it is a headline on the page consisting of just a single large sized word, making it an important element. This section uses *Chromium One*, and old-fashioned typography used in letraset in the eighties and which is powerfully highlighted. *Chromium One* also appears in fashion editorial headlines because they usually have a name as a heading, but not because it has a functional meaning. Thus, it is a good place to play with a little less readable font.

There is no point in seeking a philosophy or a rationale to explain what leads *Neo2* to show us such a wide range of intentionally selected fonts. In the field of typography in graphic design, there are classic standards that must be learnt, but once learnt they can be overlooked, as long as there is a reason for it. That is exactly what they do in *Neo2*.

Looking back, they have realised that one of the keys to operating is to have done everything without rushing, little by little, enjoying each stage, without losing that playful perspective with which they began this publishing venture.

In the same spirit they have addressed an issue in high demand by their readers: the online presence of *Neo2*. Until now, *Neo2*'s online page has been basically testimonial, although they have included certain details, like free downloads of fonts from Ipsum Planet and other typographers, who not only made their online presence distinct but made their web a place for pilgrimage for many graphic designers worldwide. But the time has come to take another small step in the evolutionary path of *Neo2*. The time has come to redefine their presence in the internet. In July 2008, they began a formal and conceptual redesigning of their web. The idea was not to dump all the paper contents, but to create a genuine online version, taking advantages of the media features: immediacy, timeliness and interactivity with the reader. *Neo2* Blog would generate daily news related to creative contents they developed on paper: art, fashion, music, graphic design, gastronomy, industrial design, cinema, literature, cosmetics, lifestyle. They applied the same rigor in the selection and dissemination of news that has always characterised *Neo2*. Their wish is to maintain the internet as clean as possible, not contaminate it even more with information already published. All that you will find in *Neo2* Blog will be first hand news, always analysed from the personal viewpoint of the editors.

On the web, you will still be able to count on a section for downloading new and old typographies, as well as pdf documents with the monthly specials from each issue and other surprises which will gradually be incorporated. The philosophy: better to have a little that is good than a lot that is bad. And, of course, *Neo2* will continue to appear monthly in kiosks with original and exclusive productions.

Berthold City American Typewriter Monoline Script Din Paper

Neo2. Page "Adeneos" Din Big Caslon Avenir Chromium One Avenir *Neo2*. Page "Explosion"

The typefaces in use depend on the section.

Regular sections: (editorial, staff, review, suscription). Headlines: *Falstaff*. Bodytext: *Avenir*. **"Adeneos":** Headlines: *Big Caslon*. Bodytext: *Avenir*. **Articles:** Headlines: *Falstaff* or *Benguiat*. Bodytext: Avenir. **Fashion editorials:** Headlines: *Chromium One*. **Explosion:** Headlines: *Chromium One*. Bodytext: *Avenir*. **Agenda:** Headlines: *Berthold City, Hang the Dj, Din, American Typewriter*. Bodytext: *Din* and *American Typewriter*. **Free typeface page:** the typeface they give away.

The New York Times Magazine

Editor: **Gerry Marzorati**
City / Country: **New York / USA**
Founded in: **1896**
Design Director: **Arem Duplessis**
Art Director: **Gail Bichler**
Deputy Art Director: **Leo Jung**
Designers: **Nancy Harris Rouemy**, **Hilary Greenbaum**, **Catherine Gilmore-Barnes**, **Jeff Docherty**, **Ian Allen** and **Leslie Kwok**
Dimensions: **225 x 275 mm**
Number of pages: **Variable**
Language: **English**
Periodicity: **Weekly**
Website: **www.nytimes.com/magazine**

THE ARCHITECTURE ISSUE

The New York Times Magazine

JUNE 14, 2009

INFRASTRUCTURE!

(IT'S MORE
EXCITING
THAN
YOU THINK,
ACTUALLY)

HOW WE CAN BUILD A **BRIDGE** — AND A **HIGH-SPEED** RAIL, AND A **BROADBAND** GRID, AND LOTS, **LOTS MORE** — TO THE 21ST CENTURY.

CLASSIC

CUSTOM TYPE

HEADLINE DESIGN

The *New York Times Magazine*, since 1896, the year when it was founded, has boasted about an excellent high level in journalism, art and photography. Before us is a weekly publication covering subjects such as politics, world events, general interest subjects, Hollywood, art or culture. The distribution is linked to *The New York Times Sunday* newspaper. What gives the magazine a touch of exclusivity, according to the criterion of its editor, Gerry Marzorati, is its conceptual approach in illustrating the magazine contents, the work done by artists, illustrators and typographers and design proposals presented by collaborators. All corners are given the same attention as they are considered to be equally important and that is what gives balance to the magazine.

The typographies used are *Lyon*, designed by Kai Bernau and Christian Schwartz, *Sunday*, designed by Eric Olsen, *Stymie*, designed by Matthew Carter, *Knockout*, designed by Jonathan Hoefler and Tobias Frere-Jones and *NYTE* designed by Dino dos Santos. With the new magazine design, new fonts have been designed which better suite the new image, but maintaining some like *Stymie* and *Sunday* because the magazine identity is so related to them. *Lyon* was introduced as the body's face because they wanted an attractive, compact and at the same time modern serif. They replaced their old sans serif with a new version of *Esta*, which the designer called *NYTE*, and finally used *Knockout*, because it is condensed and allows them to do something as important as gain content space when it is limited. The philosophy or idea behind this is that the typography chosen fits in perfectly, not only with the tone but also with the story content. New fonts are normally put to use when they have a number of special subjects and it is done with the intention of giving these issues a language of their own. The typography in the *New York Times Magazine* is a characteristic feature that ensures unique fonts with a functionality that is marked by specific needs. In this way we can find specific issues like "Year in Ideas" or "Green Issue" where they have created very special fonts to provide a final personal touch. In the first one a font, inspired in wood, was created for an article about Hollywood westerns, and a sculptural typography was obtained with natural and recycled materials for the environmental section called "Green Issue". When there are exclusive rights to a typeface, its creator agrees not to allow the use of this font generally during an agreed period of time. Having these rights helps, because a publication can have a font incorporated as part of its visual language, before it appears in other publications or products.

Not being printed on cheap paper would be a dream come true: being able to see the *New York Times Magazine* published on a larger sheet of clean white paper.

Lyon Text Regular
Lyon Text Regular Italic
Lyon Text Semibold
Lyon Text Semibold Italic
Lyon Text Bold
Lyon Text Bold Italic

PISTA GEOMETRY
You'll need to start braking with your legs you see
Election Operatives
If a car pulls out then that's just your problem

Stymie Light *Italic*
Stymie Medium *Italic*
Stymie Bold *Italic*
Stymie Extrabold

Knockout Knockout **Knockout** **Knockout**

The New York Times Magazine. Article entry. April 2008.

The New York Times Magazine. Article entry. September 2008.

In *The New York Times Magazine* typography is a feature, a fact that ensures that their typefaces are unique and had been chosen by their functionality. So we can find specific issues such as "Year in Ideas" or "Green Issue", where very specific fonts were created to provide a personal final touch.

The 6th Annual Year in Ideas 12.10.06

10

Continued on Page 14

The New York Times Magazine.
Cover. December 2006.

The New York Times Magazine. Double Spread September 2007.

Chentelham NYT

Stymie Helvetica

The New York Times Magazine. Double Spread February 2007.

Stymie

Original Garamond

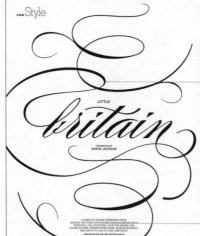

The New York Times Magazine. Double Spread September 2007.

Burgues Script

Stymie

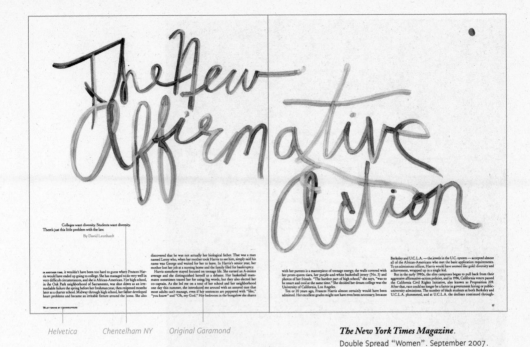

The New Affirmative Action

Colleges want diversity. Students want diversity.
There's just this little problem with the law.

By David Leonhardt

IN ANOTHER TIME, it wouldn't have been too hard to guess where Frances Harris would have ended up going to college. She has managed to do very well in very difficult circumstances, and she is African-American. For high school, in the Oak Park neighborhood of Sacramento, was shut down as an irremediable failure the spring before her freshman year, then reopened months later as a charter school. Midway through high school, her father developed heart problems and became an irritable fixture around the home. She also

discovered that he was not actually her biological father. That was a man named Leroy who, when her mother took Harris to see him, simply said his name was George and waited for her to leave. In Harris's senior year, her mother lost her job at a nursing home and the family filed for bankruptcy.

Harris somehow stayed focused on teenage life. She earned an A-minus average and she distinguished herself as a debater. Her basketball teammates sometimes teased her for using big words, but they also elected her co-captain. As she led me on a tour of her school and her neighborhood one day this summer, she introduced me around with an assured ease that most adults can't manage, even if her sentences are peppered with "like," "you know" and "Oh, my God." Her bedroom is the bungalow she shares

with her parents is a masterpiece of teenage energy, the walls covered with her prom-queen tiara, her purple-and-white basketball jersey (No. 3) and photos of her friends. "The hardest part of high school," she says, "was to be smart and cool at the same time." She decided her dream college was the University of California, Los Angeles.

Ten or 20 years ago, Frances Harris almost certainly would have been admitted. Her excellent grades might not have even been necessary, because

Berkeley and U.C.L.A. — the jewels in the U.C. system — accepted almost all of the African-Americans who met the basic application requirements. To an admissions officer, Harris would have seemed like gold: diversity and achievement, wrapped up in a single kid.

But in the early 1990s, the elite campuses began to pull back from their aggressive affirmative-action policies, and in 1996, California voters passed the California Civil Rights Initiative, also known as Proposition 209. After that, race could no longer be a factor in government hiring or public-university admissions. The number of black students at both Berkeley and U.C.L.A. plummeted, and at U.C.L.A. the declines continued through-

77

Helvetica *Chentelham NY* *Original Garamond*

The New York Times Magazine.
Double Spread "Women". September 2007.

Kina Thin *Lyon*

The New York Times Magazine. Double Spread. August 2009.
They have recently redesigned the magazine and introduced some new fonts. They kept *Stymie* and *Sunday* from the previous design because they had become part of the magazine's identity. They chose *Lyon* for their body face because they wanted a compact, modern, nicely designed serif font.

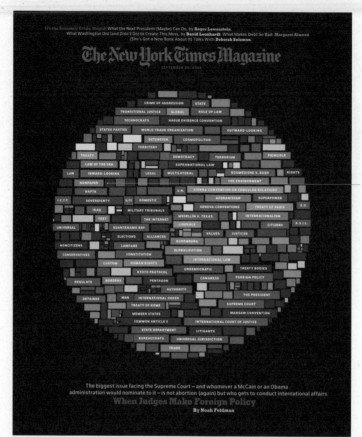

It's the Economic Crisis, Stupid! What the Next President (Maybe) Can Do, by **Roger Lowenstein**.
What Washington Did (and Didn't Do) to Create This Mess, by **David Leonhardt**. What Makes Debt So Bad: Margaret Atwood
(She's Got a New Book About It) Talks With **Deborah Solomon**.

The New York Times Magazine

SEPTEMBER 29, 2008

Sunday NYT

The biggest issue facing the Supreme Court — and whomever a McCain or an Obama
administration would nominate to it — is not abortion (again) but who gets to conduct international affairs.

When Judges Make Foreign Policy

By Noah Feldman

The New York Times Magazine.
Cover. September 2008.

The New York Times Magazine. Cover. August 2008.

The New York Times Magazine. Cover. June 2008.

The New York Times Magazine.
Double Spread
Junio 2009.

Knockout

Knockout

GETTING UP TO SPEED

NYTE Display

Lyon Text

The New York Times Magazine.
Double Spread
July 2009.

Knockout

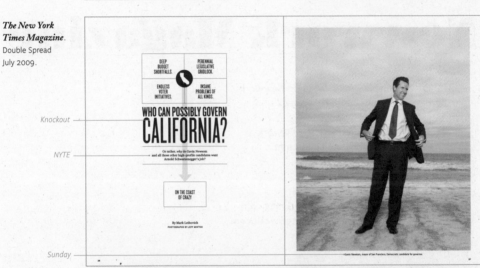

NYTE

Sunday

The New York Times Magazine.
Double Spread
August 2009.

Knockout

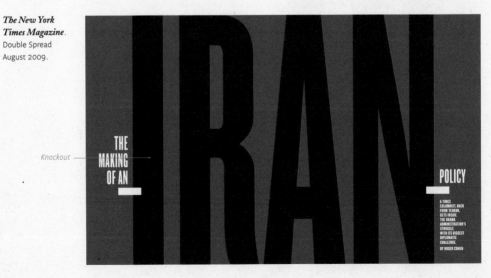

119

TypoMag / *The New York Times Magazine*

'Great type without great lay out
can't make a great design.'

Newwork Magazine

Editor / Director: **Studio Newwork**
City / Country: **New York / USA**
Founded in: **2006**
Art direction: **Studio Newwork**
Dimensions: **545 x 813 mm**
Number of pages: **120**
Language: **English**
Periodicity: **twice a year**
Website: **www.newworkmag.com**
 www.studionewwork.com

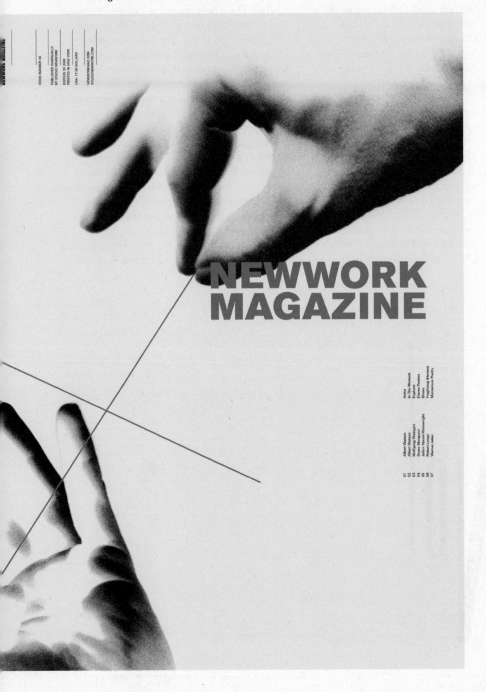

NEWWORK
MAGAZINE

ISSUE NUMBER 04

PUBLISHED BIANNUALLY
BY STUDIO NEWWORK

EDITION OF 2009
PRINTED IN NEW YORK

USA: 17.00 DOLLARS

NEWWORKMAG.COM
STUDIONEWWORK.COM

01 Albert Watson
02 Albert Watson
03 Wolfgang Weingart
04 Bruno Monguzzi
05 Julian Album Wainwright
06 Robert Longo
07 Werner Jeker

Actor
In The Moment
Explorer
Eleven Posters
Divers
YingXiong (Heroes)
Mysterious Poetry

CLASSIC

CUSTOM
TYPE

LOGO

HEADLINE
DESIGN

DESIGNER

Newwork Magazine is a large format art publication which carries a big bunch of fresh ideas under its arm. Designed and published by Studio Newwork, and appearing twice a year, each issue shows us new creations from a wide choice of artists and creators from the world of fine arts, design, high fashion, and culture. From art directors to relevant personalities in the business world, to design students and art gallery and museum curators, to all those who play their part working with *Newwork Magazine* are united in their desire to go beyond the limits of their personal areas. Among the features to highlight in this magazine are the tailor made bold typographies and a change in format of the traditional newspaper, offering us a stimulating proximity between a surprisingly impressive design and the very simple everyday life.

They consider their magazine to be a good broadcasting medium where they can share what they believe in and feel proud of being able to do so. With its headquarters in New York, its name commemorates the name of the skyscraper city. Four designers are responsible for the design, from the first to the last page of the magazine (Ryotatsu Tanaka, Ryo Kumazaki, Hitomi Ishigaki and Aswin Sadha). The whole magazine bears the personal seal of the designers and they feel honoured and committed to the fact that great artists, designers and photographers join forces with them. Once they decide the subject to be dealt with, relevant partners are chosen. Then, they stay with the work that the artist, designer or photographer has done, or they work together with him or her to achieve harmony.

A slight change in size may be appreciated in issue number four as it is smaller than usual. Typefaces like **Berhold Akzidenz Grotesk**, **Linoytype Universe** and **Akkurat** count among those chosen. Other custom made types are responsible for illustrating the front cover of different sections in an attempt to give a personal touch to the work. In order to improve with each issue, they are aware that they run

Newwork Magazine. Double Spread. Issue 1. Spring 2008. In this spread the designers used custom typefaces for the entries. This makes it unique.

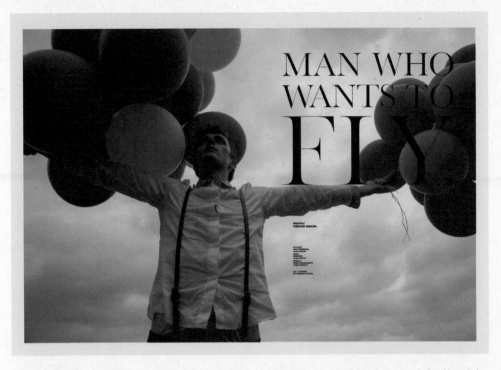

Newwork Magazine. Double Spread. Number 1. Spring 2008. This men's fashion story is entitled "Man who wants to fly." and it reminds us of the human dream of flying. The contrast between thick and thin, large and small in typography enriches this romantic story making it more masculine and elegant.

the risk of the reader not easily identifying the publication when there are significant changes affecting the aesthetics. But if they want to improve the appearance of the magazine then that is a risk that must be taken.

By being able to separate all the pages and present each part individually, each section of the magazine can be hung on the wall as if it were a work or art.

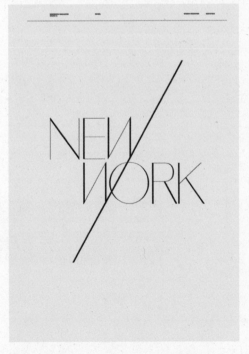

Newwork Magazine. Single Page. Number 1. Spring 2008. The current location of the studio, New York, is hidden in words "NEW WORK" in the cover design.

Project III
Columbia GSAPP
lecture series posters

F'84

S'85

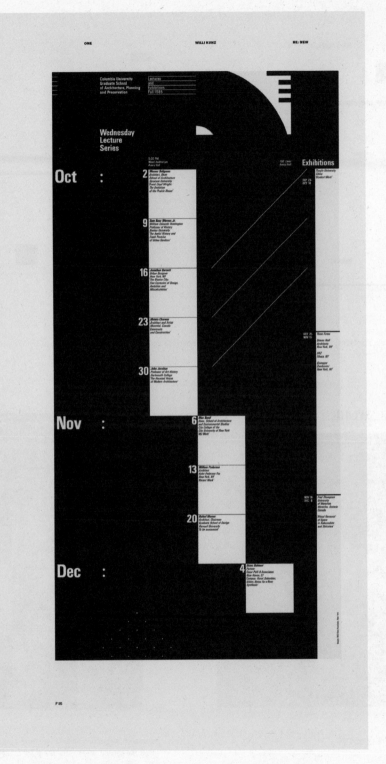

Newwork Magazine. Double Spread. Issue 1. Spring 2008. The body text and the shapes have two different rhythm. When they are merged into one, it creates stronger rhythm.

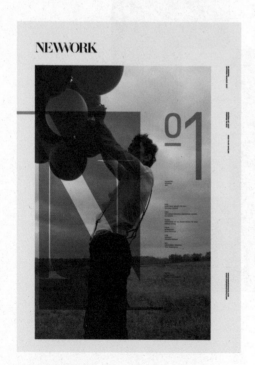

Newwork Magazine. Cover. Issue 1. Spring 2008.

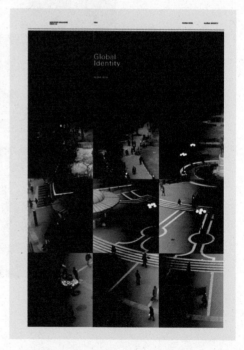

Newwork Magazine. Single Page. Issue 2. Fall 2008.
This is the section cover of the showcase of the artist Reona Ueda.
A three column grid is applied to the image and typography on the cover design.

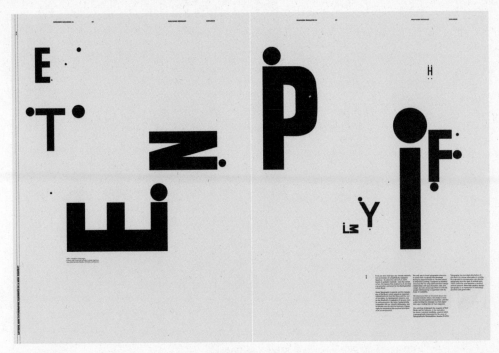

Newwork Magazine. Covers. Issue 4. Fall 2009.The typographic composition has beed designed by Wolfgang Weingart. They emphasize its dynamic typesetting letters using the contrast between large and small texts.

Newwork Magazine. Single page. Issue 3. Spring 2009.
Wolfgang Weingart's signature gives human touch to this cover design and strong contrast to his letter "M" study.

Newwork Magazine. Single page. Issue 3. Spring 2009.
Hawaiian underwater photographer Wayne Levin's work reflects warm and delightful hawaiian ocean.The script typeface is designed to express smooth flow and pleasant waves.

Nico

Publisher / Editor in chief: **Mike Koedinger**
Fashion Editor: **Angelina A. Rafii**
Managing Editor Paris: **Philippe Graff**
City / Country: **Luxembourg**
Founded in: **2007**
Art Direction: **Guido Kröger** & **Maxime Pintadu / INgrid.eu**
Dimensions: **230 x 280 mm**
Number of pages: **+-230**
Languages: **English / French**
Periodicity: **Biannual**
Website: **www.nicomagazine.com**

Nico. Cover. Number 4. 2010. Illustration: Yulia Brodskaya

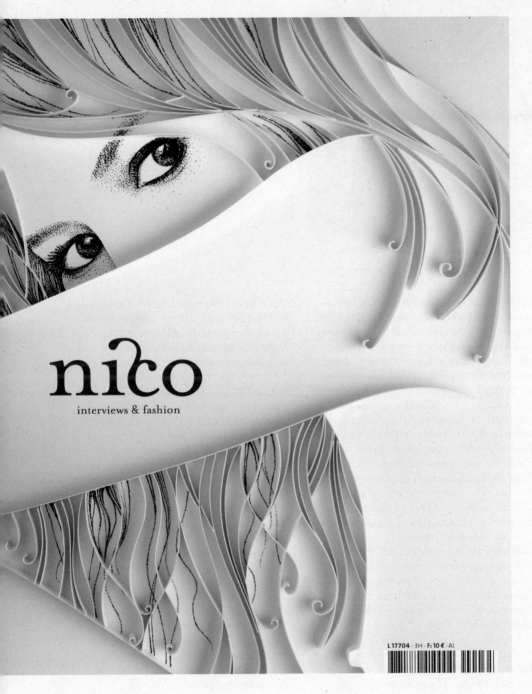

L 17704 · 3H · F: 10 € · AL

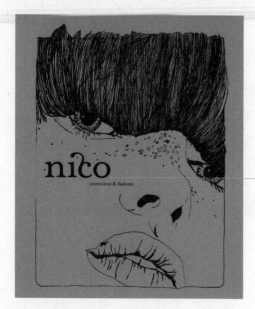

— Mrs. Eaves

Nico. Cover. Number 1. Summer 2007. Illustration: Christina K.

In *Nico* we can find the ideal blend of fashion and interviews with a powerful editorial which presents new, emerging talents in the world of fashion, photography, art, design, illustration and all the creative industry in general. *Nico*, which has recently arrived from Luxembourg and is edited and directed by Mike Koedinger, is an excellent springboard for creative minds with talent, be they journalists, photographers, stylists or illustrators. It offers readers a unique blend of pop culture, exclusive interviews, full of sincerity and fantastic photography. *Nico*, whose name reminds us of the German singer from the sixties, offers great quality and excellent production and is a beautiful name that could be given to either a man or a woman. The texts and images that appear in the publication are definitely its best attraction. They are areas where the magazine reaches it maximum quality, primarily emphasising the profound respect felt for the work of the different artists who collaborate or have collaborated with them.

Retaining the size of the magazine, with which they are pleased and see no need to change, aspects like the type of paper, change with each number. The three typefaces that appear in the magazine are **Mrs. Eaves**, **Janson Text** and **The Sans** with no changes planned in this aspect either. **Mrs. Eaves** was designed by Zuzana Licko in 1996 and was her first attempt at creating a traditional typeface inspired in *Baskerville*, the famous traditional typeface designed by John Baskerville in 1757. Licko reduced the contrast but maintained its openness and lightness, giving the lowercase a greater proportion. **Mrs Eaves** presents a classic design with some simple, but beautiful features. **Mrs. Eaves** creates a pleasing harmony and fluidity between the text and the headline. **Janson Text**, designed by Linotype Design Studio in 1985, is the typeface which is mainly used in texts; it has sturdy legible features with a strong contrast in the stroke. **The Sans**, with no marked differences between thick and thin strokes, perfect for titles and captions, is the third typeface in use in *Nico*. Designed by Lucas de Groot in 1994, it forms part of the **Thesis** super family.

Their working motto is "less is more" and mainly opts for a magazine that is legible, attractive and read for pleasure. A cover with no photos seeks to arouse the curiosity of inquisitive readers.

FELIPE OLIVEIRA BAPTISTA

The Storyteller

Si son nom est loin d'être inconnu des *fashionistas*, Felipe Oliveira Baptista reste une personnalité dont on sait finalement peu de choses. Il faut dire que le jeune homme n'est pas de ces créateurs égocentriques à se mettre constamment en scène. Son talent n'a d'égal que sa discrétion et son humilité. En une poignée d'années, il a su imposer une mode structurée aux lignes pures et modernes, dynamitée par des volumes surprenants. Rapidement plébiscitées, ses collections sont présentées depuis 2005 pendant la semaine de la Haute Couture à Paris.

Entretien réalisé par Justin Morin. Photographie de Valérie Archeno.

En novembre dernier, quelques jours après que notre interview eut lieu, se déroulaient deux concours importants pour l'industrie de la mode européenne, les *Mango Fashion Awards* (Espagne) et le *Swiss Textiles Award*, pour lesquels Felipe était sélectionné. Aujourd'hui, le mystère qui voilait les résultats n'est plus, et l'on sait qu'il s'a malheureusement pas gagné. Bien conscient du facteur chance qui favorise le candidat lauréat face à ses concurrents, Felipe Oliveira Baptista considère ses nominations comme des récompenses, et nous avouait: « Je ne cherche pas vraiment à poser dans un pays donné ou à tout prix, car l'argent ne permet pas vraiment de fidéliser une situation. Les jeunes créateurs évoluent dans des structures économiques fragiles. Mais même si je ne gagne pas, je suis heureux d'avoir été sélectionné. La personne n'est pas simple, mon équipe et moi avons évidemment traversé des périodes difficiles, ce qui est commun à tous les créateurs. Être aujourd'hui

emvisagé pour ces récompenses, c'est un signe de soutien et de reconnaissance qui compte énormément. »

Gageons que d'autres opportunités de ce genre se présenteront rapidement à lui. D'ici là, savourons la rencontre avec Monsieur Felipe Oliveira Baptista.

Vous présentez votre première collection pendant le Festival des Arts de la Mode de Hyères, mais on connaît assez mal vos débuts. On lit ici et là que vous auriez fait des études d'architecture.

Mais je n'ai pas fait d'étude d'architecture! (Rires) C'est une rumeur fâcheuse qui court sur moi, j'ai effectivement lu ça plusieurs fois dans la presse, mais ce n'est pas vrai. Je suis né en 1975 au Portugal, j'ai quitté Lisbonne alors que j'avais 18 ans pour faire une classe préparatoire artistique à Londres, à la Kingston University. Je ne savais pas vraiment dans quoi me spécialiser, cette formation m'a permis de toucher un peu à tout: photographie, graphisme, mode... Je me suis finalement décidé pour la mode. J'ai donc passé trois ans en Angleterre à étudier. J'ai ensuite travaillé chez Max Mara, en Italie, pendant un an avant de venir sur Paris. Je suis passé chez Cerruti et Thimister, tout en faisant parallèlement quelques boulots en dehors de la mode (les pochettes de disques, de la photographie, du graphic design... Et finalement, en 2002, j'ai présenté ma première collection sous mon propre nom à Hyères.

Qu'est-ce qui vous a fait choisir la mode plutôt qu'une autre discipline?

C'est un miracle que je ne pensais pas très au sérieux avant d'arriver à Londres, car au Portugal ce n'est pas vraiment vu comme un métier. Là-bas, il n'y a pas vraiment d'industrie de la mode, et encore moins de possibilité de carrière. À Londres, la mode est un milieu naturel que les autres arts appliqués. Je crois que j'aime la mode car elle touche un peu à tout, elle mélange plusieurs disciplines de la photo, de la sculpture – j'appréciais énormément le travail du volume – de la mise en scène. C'est un peu comme raconter une histoire.

Qu'est-ce qui vous a amené à Hyères, sachant que jusqu'à alors vous travailliez pour d'autres?

J'ai toujours eu envie de faire ma propre marque, notamment pour créer un univers qui me

nico 27

Mrs. Eaves Janson Text Roman & Bold

Belle de Jour

Photographer **Zoren Gold & Minori**
Stylist **Rie Edamitsu**
Model **Minori**
Represented by **Madé (Paris)**

Vintage Suit CORDIA

nico 129

Thesis The Sans

OASE

Editorial Team: **Tom Avermaete**, **Pnina Avidar**, **David de Bruijn**, **Joachim Declerck**, **Job Floris**, **Christoph Grafe**, **Klaske Havik**, **Anne Holtrop**, **Johan Lagae**, **Ruben Molendijk**, **Hans Teerds** and **Gus Tielens**
Editor: **NAi Uitgevers**
City / Country: **Rotterdam / The Netherlands**
Founded in: **1983**
Art Direction / Graphic Design: **Karel Martens / Werkplaats Typografie, Arnhem**
Dimensions: **170 x 240 mm**
Number of pages: **144**
Languages: **Dutch / English** (since num. 45)
Periodicity: **quarterly**
Website: **www.oase.archined.nl**

OASE #63. Cover. Spring 2004. Design by Karel Martens and Aagje Martens.

PLAT-
TE-
LAND
#63
COUN-
TRY-
SIDE

CLASSIC

IDENTITY

LOGO

HEADLINE
DESIGN

DESIGNER

OASE is an independent international bilingual magazine (it is published in Dutch and English) presenting architecture, urban and landscape design. Published by NAi Publishers and commissioned by the *OASE* foundation, what makes it different from similar publications is the depth and breadth of the thoughts given to its subjects.

Karel Martens, graphic designer of *OASE*, manages to include such apparently contradictory concepts in his work as order and freedom. He finds inspiration just on the limits of his profession and converts obstacles into challenges. His magazine is a clear example of how a designer can manoeuvre in the narrow, limited field of graphic design production. *OASE* turns out to be somewhere between a book and a magazine and each issue reinvents its forms to the surprise of its readers. Karel gave the magazine a clear direction which has been convincing in the way he has been able to create a magazine that brushes up against luxury and modesty at the same time and makes us believe that a low budget publication can become a valued object for collection. The grid became a fascinating element for Karel Martens, giving the most basic element in graphic design an active role which clearly reflects the tone of the magazine.

Originally, *OASE* had an A4 format. But given that the approach was mainly theoretical, a book format was later chosen. The reasons for this change lie in the difficulties of continuing with the old format, as most of the pages were loose pages where students handed in their essays. Despite being very attractive and appreciated, it was a problem and so it was decided to change to a book rather than magazine format because there was a lot of text and it is easier to read a book format than magazine. The most economical size for 50 x 70 cm presses in The Netherlands is 24 x 17 cm.

When the *OASE* production changed, the 6 x 2 mm grid did as well. Now it is completely produced by Macintosh giving a lot more opportunities for adjusting columns, typography and margins. If you take enough time to look closely at the magazine and focus on its internal structure it gives the impression that the grid changes with each issue, as does the paper and the typography. But these changes are so subtle that they cannot be seen from one issue to another, you need to see a series of issues to be able to compare the first and last and then be able to see the differences. Within the basic typographies there is an attempt to maintain the **Monotype Grotesque** and **Janson**, but there are exceptions, given that the grid changes when there is a change of format, e.g. an issue on poetry is a different size than one on architecture. The grid and its division depend on the complexity of the issue. The last two are bilingual and so the grid had to be adapted to accommodate larger amounts of text. In an issue where texts in English and Dutch are the same, another change of grid is also required and that is what they are working on in number 49 of *OASE*.

The same number of pages was kept when the magazine became bilingual, making the typography smaller and smaller. However, the combination of the two languages and the limitations of space were turned into an advantage. As there is no aesthetic commitment

OASE #67. Cover and backover. Fall 2005.
Design by Karel Martens and Aagje Martens.

OASE #49 / #50. Cover and backover. Winter 1999.
Design by Karel Martens and Patrick Coppens.

was a body falling.
Strangers who had
reamed as they fell
, smoke and steam ris-
, death.'¹
people. We relate to
nteractions with peo-
le (that is, our bodies
nvironments we
sping meaning hap-
ur conscious control.

lwell on *terra firma,* we
ces of this embodi-
eaning for us is a
s of environments we
actices and institu-
us of human under-
an organism in an
nvironments.
the heart of this organ-
d, it is spatial and bodi-
re-reflective bodily

1
George Lakoff, 'Metaphors
of Terror', unpublished
essay, University of
California, Berkeley,
September 16, 2001.

die iemand door zijr
bloed dat aan de anc
toren die omviel wa:
ikzelf, mijn familie,
geglimlacht toen ze
langs me heen. Het
stoom, het skelet va

Gebouwen word
gebouwen een diepe
met medemensen. I
ons lichaam en onze
terechtkomen. Dit c
nen gebeurt op een
dit werkt.

Hoe betekenis
Menselijke wezens z
zijn we lichamelijk.
de consequenties: w
hebben is het gevolg
waarin we opgroeier
waarin we functione
organisme in een co
omgevingen is de lo
De architectuur t

Monotype Grotesque

Janson Text Roman

OASE #58*.* Summer 2002. Detail in actual size. Design by Karel Martens, Connie Nijman and Alex Mckeithen.
As a basic typefaces Karel Martens use *Monotype Grotesque,* for English texts, and *Janson* for the Dutch, but there are exceptions, and we can
see how the designers use other typefaces as *Akzidenz Grotesk, Franklin Gothic* or *Walbaum.*

in *OASE*, every edition works, even with those limitations. According to Karel Martens, constraints are essential in design because it offers solutions. They can even be enjoyed. Now everything is easier as there are not as many constraints as there were at the beginning. *OASE* is a low budget publication and they know that if, for example, they change the paper, they may add more colour to the cover or that if they reduce the size, more pages could be added, but *OASE* public is always the same and they can't be cheated because they are faithful readers who do not want to have the same magazine with just a different cover. It is much more respectful with its public and something different is always prepared so the readers are always awaiting the next issue with impatience.

When we ask Karel why the *OASE* has such a typical Dutch appearance, he looks surprised and admits that he would love to know the reason for it. However, it is justified by the diversity forms, by the plurality which allows them to take decisions on each occasion on an individual basis. We may find the reasons in the flexibility that exists in a country as small as his.

TypoMag / *OASE*

135

Dirk Sijmons / Lodewijk van Nieuwenhuijze

Contours: In Aqua Scribis?

Introduction
The *Fifth Memorandum on Physical Planning* in the Netherlands introduced a zoning system consisting of red contours, green contours and balance zones. The government has various reasons for introducing this new instrument. Primarily, its aim is to counter the wasteful use of space by reducing urban expansion – specified by the red contour. As a result of this, the erosion and fragmentation of open space will – hopefully – also be brought to a halt. The aim of the green contour is, at a national level, to safeguard extremely valuable areas from change (Ecological Main Structures, including the men-made landscapes that form part of them, such as Bird Directive and Habitat Directive areas). This article examines the possible advantages and the expected risks and disadvantages of the contour approach.

The new contour instrument will have to fit into the existing set of Physical Planning instruments and the planning culture that has developed in relation to them. How can this new, simple-looking instrument achieve its goals in a highly complex and multilayered situation? Will it be a stimulus to intensive and multiple use of space? What are the opportunities and risks involved in superimposing this instrument on the existing physical planning practice?

How do contours work?
A contour makes distinctions on the basis of functions: on one side of the line a particular function is allowed, on the other side it is not. Contours are essentially a classic zoning instrument born out of the Anglo-Saxon planning tradition. They are instruments which are principally connected to authorisation planning (and without a flanking policy such planning relates poorly to the implementation planning embraced by the Fifth Memorandum). Considering their simplicity they work best in a relatively empty planning landscape. The zoning laws in the USA were originally intended to keep high-risk areas (such as flood areas) and high-value areas (national parks) free from building. Later, several levels of administration and government institutions started employing zoning regulations which led to a fragmented set of orders and prohibitions. Local governments used zoning mainly to set up barriers against the establishment of particular (financially weaker) groups in their area. Zoning has become an instrument of social segregation.

Contouren: in aqua scribis?

Inleiding
De Nederlandse *Vijfde Nota Ruimtelijke Ordening* introduceert een zoneringstelsel bestaande uit rode contouren, groene contouren en balansgebieden. De motieven voor dit nieuwe instrument zijn divers. Allereerst beoogt men het tegengaan van spilziek ruimtegebruik door de uitbreidingsruimte voor stedelijke functies te beperken middels de rode contour. In het verlengde daarvan hoopt men de aantasting en versnippering van open ruimte tot staan te kunnen brengen. Als sluitstuk beoogt men door de groene contour op een national niveau de zeer waardevolle gebieden (Ecologische Hoofdstructuren - inclusief de cultuurlandschappen die daarvan mede deel uitmaken – zoals Vogelrichtlijn- en Habitatrichtlijngebieden en cultuurhistorische topstukken in de sfeer van het landschap) te vrijwaren van ingrepen. In dit artikel worden de mogelijke voordelen en de verwachte risico's en nadelen van de contourbenadering tegen het licht gehouden.

Het nieuwe instrument van contouren zal zich moeten voegen in het bestaande instrumentarium van de ruimtelijke ordening en de planningscultuur die daarin is ontwikkeld. Hoe kan dit nieuwe, simpel ogende instrument in een zeer complexe en gelaagde werkelijkheid zijn vruchten afwerpen? Zal het nieuwe instrument een stimulans betekenen voor intensief en meervoudig ruimtegebruik? Welke kansen en risico's zijn er bij het superponeren van dit instrument op de bestaande ruimtelijke-ordeningspraktijk?

Hoe werken contouren?
Met een contour wordt op basis van functies een onderscheid gemaakt: aan de ene kant van de lijn is een functie toegestaan, aan de andere kant verboden. Contouren zijn in wezen een klassiek zoneringsinstrument, geboren in de Angelsaksische planningstraditie. Het zijn instrumenten die ten principale zijn verbonden met toelatingsplanologie (en die zich zonder flankerend beleid slecht verhouden tot die in de Vijfde Nota omarmde uitvoeringsplanologie). In hun eenvoud werken ze optimaal in een relatief leeg planningslandschap. De *zoning laws* in de Verenigde Staten dienden oorspronkelijk om gebieden met hoge risico's (*flooding areas* en dergelijk) of hoge waarden (*national parks*) vrij te houden van bebouwing. Later zijn meerdere bestuursniveaus en overheidsinstellingen *zoning regulations* gaan hanteren, waardoor een gefragmenteerd geheel van geboden en verboden is ontstaan. Lokale overheden hebben zonering vooral gebruikt

Akzidenz Grotesk Medium *Akzidenz Grotesk Regular*

Monotype Grotesque *ITC Franklin Gothic*

OASE #63. Cover and backcover. Spring 2004. Design by Karel Martens and Aagje Martens.

In 2008, *OASE* celebrated its 25th anniversary. This is the poster that was published for the ocassion. Designed by Karel Martens and Scott Ponik.

Paper Planes

Editor / Director: **Carlos Ramírez**
City / Country: **Barcelona / Spain**
Founded in: **2009**
Art Direction / Graphic Design: **Íñigo Jerez** and **Ana Mirats**
Dimensions: **230 x 420 mm**
Number of pages: **240**
Language: **English**
Periodicity: **Biannual**
Website: **www.paperplanesmagazine.com**

BY HAND

PAPER
PLANES
#02

CUSTOM TYPE

LOGO

HEADLINE DESIGN

TRIKE

OSE

N. WINTER 2009
CE 10 €

TypoMag / *Paper Planes*

Poster

Point

Paper Planes. Single page #01. Spring / Summer 2009.
The typefaces used are designed for the magazine according to the subject. In this number the designers used *Point*, a personal interpretation of the *American Typewriter*, a typography which gives off a juvenile air and reflects the characteristics of a typewriter in a sophisticated way. Finally, a display version of *Poster* was adjusted, a typography style far from the original style but used in lower case giving an almost childish touch to the headlines.

Paper Planes. Double Spread #01. Spring / Summer 2009.
The calligraphic *lettering* reproduces the editor's intervention on the magazine.

Paper Planes. Double Spread #01. Spring / Summer 2009.

En *Paper Planes* #01, el guión gráfico detrás del tema "Forever Young" era la descomposición de un cartapacio, la típica pieza adolescente donde uno guarda parte de sus "momentos"; esa idea evolucionó hasta convertirse en la desfragmentación de la carpeta de trabajo del editor (al fin y al cabo el tema partía de sus obsesiones ya que a su editor jefe le apasiona la música) y para recrear ese concepto se recurrió a un *lettering* de estilo caligráfico, una simulación gráfica de los pensamientos y apuntes del editor; junto a ese letterin

Paper Planes. Double Spread #01. Spring / Summer 2009.

Paper Planes, published in English, began as an editorial project all about fashion and directed at a sector related public, that is, communication agencies, stylists, designers, fashion historians and, why not, all those who are "backstage" and not given sufficient attention. In short, a biannual magazine dedicated to people who specialise in this world, it is a fashion manifest for fashion. Its original atypical starting point in each issue is a song and the year it was published. This song is presented as the editorial letter and becomes the axis around which contents are organised. At the same time it serves as a briefing for the photographers, with a lot of weight and presence in the magazine, to make a personal interpretation of it.

The typefaces used are designed for the magazine according to that theme, a song and everything that surrounds it: period, musical style, fashion, etc. This relationship between typography and the concept of each issue is so subtle that it is sometimes undetectable. To understand it, lets take an example. In *Paper Planes* #01, the storyboard behind the theme "Forever Young" was the decomposition of a portfolio, the typical adolescent piece where

you keep part of your "moments." That idea evolved into fragmenting the editor's work folder (after all the theme came from his obsessions as his chief editor is mad about music) and to recreate this concept they used a calligraphic style of lettering, a graphic simulation of the editors thoughts and notes; together with this lettering, **Point** was used, a personal interpretation of the *American Typewriter*, a typography which gives off a juvenile air and reflects the characteristics of a typewriter in a sophisticated way. Finally, a display version of **Poster** was adjusted, a typography style far from the original concept but used in lower case giving an almost childish touch to the headlines. Not everything should be obvious.

Paper Planes designers do not decide the contents, but they formalise them, that is to say, they decide how the public receives the information. Among the countless ways of laying out contents or ordering and framing an editorial, the designers' responsibility is to define how visible their work will be and this visibility varies in *Paper Planes* according to content. Editor and designers must listen and mutually understand one another. The project

WITH AN ATTITUDE
FELLOWS THAT WERE IN THE MOOD
DON'T JUST STAND THERE
LET'S GET TO IT

STRIKE A

Paper Planes. Double Spread #02. Fall / Winter 2009.

Paper Planes. Double Spread #02. Fall / Winter 2009.

Paper Planes. Double Spread #02. Fall / Winter 2009.
Detail in actual size.

offered must be consistent and for this there must be a balance between the various factors that interact in the development of a magazine. The more particular the balance, the more extraordinary is the result and the objective will be achieved: to be able to make every issue new, unique and different in graphic, photographic and conceptual style.

With changes ranging from the logotype to the typography, each issue is created from scratch. Special types are designed, reconsidering the use of them and the layout, giving more design freedom and consistency. It is a privilege for them to be able to consider each issue as a new project and achieving that exclusivity, which is part of the magazine's philosophy, to decide and adjust the typography of each issue so that these are "unique." This helps transmit *Paper Planes'* message.

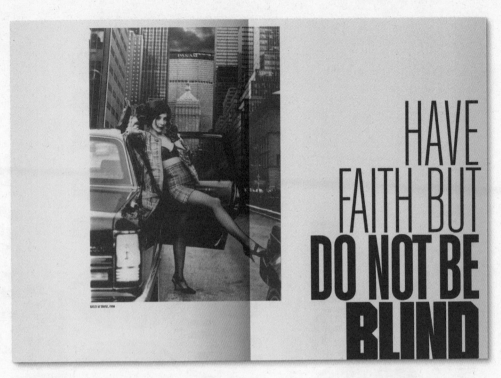

Paper Planes. Double Spread #02. Fall / Winter 2009.

NGga3!

NGga3!

NGga3!

NGga3! NGga3! **NGga3!**

NGga3!

Being a fashion magazine it is fundamental to have an image on the front page that changes with each issue. If the script changes with each issue, it is logical that the heading adapts to this script. That is why *Paper Planes* is not a brand; it is much more than a logo. And if it were a brand it would not only include the publishing territory, but could be extended to other fields such as the design studio, a creative consultancy, a record label, or a brand of clothes.

For *Paper Planes* #02 they designed a set of condensed typefaces that pretend to be a graphic tribute to New York, an indispensable reference for the world of fashion, and the city where "voguing" is developed in an underground way. On the other hand, they also designed a stencil "didone" with three degrees of condensation. This type is a direct reference to the logo of *Vogue*, a classic icon for the sector, the stencil intervention is a subtle irreverence that contrasts with the elegance of these fonts and subtly connects with the more irreverent side of the "voguing" movement. Finally, the set is completed with an extrablack weight of a typical American condensed. None of these typefaces yet has a name.

" YOU KNOW. I THINK I'M IN STATE OF SHOCK. I KNOW THE TOUR IS OVER BUT IT'S… IT'S LIKE LAST WEEK IN SPAIN I REALLY FELT… I WOULD HAVE A NERVOUS BREAKDOWN. I COULDN'T TAKE THE CROWS OUTSIDE, I COULDN'T DO THE SHOWS. EVERYTHING WAS GETTING TO ME I'M GETTING

Paper Planes. Double Spread #02. Fall / Winter 2009.

PAPER PLANES #02

TYPEFACES

PAPER PLANES#02 **Stencil** condensed, Semi-condensed & Normal.
Slim condensed light, regular & Bold. **School** black

READY FOR THE DIPRESSION,
I'LL FEEL WHEN THE **TOUR'S OVER,** BUT I REALLY DIDN'T FEEL **EMOTIONAL** LAST NIGHT.
I KNOW EVERYBODY ELSE DID AND EVERYONE WAS **CRYING,**
BUT I DIDN'T FEEL **EMOTIONAL** 99

(**MADONNA,** TRUTH OR DARE)

0125456789 ½½½¾½¹²³
ABCDEFGHIJKLMNOPQRSTUVWXYZ
ÁÀÄÂÃÅÇÈÉÊËÌÍÎÏÑÒÓÔÕÖÙÚÛÜ&
abcdefghijklmnopqrstuvwxyz
áàäâãåçèéêëìíîïñòóôõöùúûü
$€£¥ƒ¿?¡!()[]{}☆ ❀◌........~

0125456789 ½½½¾½¹²³
ABCDEFGHIJKLMNOPQRSTUVWXYZ
ÁÀÄÂÃÅÇÈÉÊËÌÍÎÏÑÒÓÔÕÖÙÚÛÜ&
abcdefghijklmnopqrstuvwxyz
áàäâãåçèéêëìíîïñòóôõöùúûü
$€£¥ƒ¿?¡!()[]{}☆ ❀◌........~

0125456789 ½½½¾½¹²³
ABCDEFGHIJKLMNOPQRSTUVWXYZ
ÁÀÄÂÃÅÇÈÉÊËÌÍÎÏÑÒÓÔÕÖÙÚÛÜ&
abcdefghijklmnopqrstuvwxyz
æœfiflß§ ªº.DOI.IŚSŸÞŽŻŠŸµOø.
$€£¥ƒ¿?¡!()[]{}☆ ❀◌........~

0123456789 ½½½¾½¹²³
ABCDEFGHIJKLMNOPQRSTUVWXYZ ÁÀÄÂÃÅÇÈÉÊËÌÍÎÏÑÒÓÔÕÖÙÚÛÜ
abcdefghijklmnopqrstuvwxyz áàäâãåçèéêëìíîïñòóôõöùúûü
æœfiflß@ ªº $€£¥ƒ¿?¡!()[]{}☆ ❀◌........~

0123456789 ½½½¾½¹²³
ABCDEFGHIJKLMNOPQRSTUVWXYZ ÁÀÄÂÃÅÇÈÉÊËÌÍÎÏÑÒÓÔÕÖÙÚÛÜ
abcdefghijklmnopqrstuvwxyz áàäâãåçèéêëìíîïñòóôõöùúûü
$€£¥ƒ¿?¡!()[]{}☆ ❀◌........~

0123456789 ½½½¾½¹²³
ABCDEFGHIJKLMNOPQRSTUVWXYZ ÁÀÄÂÃÅÇÈÉÊËÌÍÎÏÑÒÓÔÕÖÙÚÛÜ
abcdefghijklmnopqrstuvwxyz áàäâãåçèéêëìíîïñòóôõöùúûü
$€£¥ƒ¿?¡!()[]{}☆ ❀◌........~

0123456789 ½⅓½¾¹²³
ABCDEFGHIJKLMNOPQRSTUVWXYZ.ÁÀÄÂÃÅ
ÇÈÉÊËÌÍÎÏÑÒÓÔÕÖÙÚÛÜÕ§
abcdefghijklmnopqrstuvwxyz.áàäâãå
çèéêëìíîïñòóôõöùúûü
$€£¥ƒ¿?¡!()[]{}☆ ❀◌........~
-×÷<=>~¬†‡°‰%‰

AaAaAa
AaAaAaAa

www.bextaxis.com

PIN-UP

Editor / Director: **Felix Burrichter**
City / Country: **New York / USA**
Founded in: **2006**
Art Direction / Graphic Design: **Dylan Fracareta**
Dimensions: **235 x 285 mm**
Number of pages: **ca. 150**
Language: **English**
Periodicity: **Biannual**
Website: **www.pinupmagazine.org**

PIN—UP

Featuring
PETER MARINO,
BEN VAN BERKEL,
KEN KELLOGG,
R&SIE(N), WILLIAM
KATAVOLOS,
DAVID ADJAYE,
and SAADABAD.

MAGAZINE FOR
ARCHITECTURAL
ENTERTAINMENT

With a special
tribute to
HERBERT
MUSCHAMP.

ISSUE 5
Fall Winter 08/09

US$ 10.00
EUR 9.90

ISSN 19339755

9 771933 975000

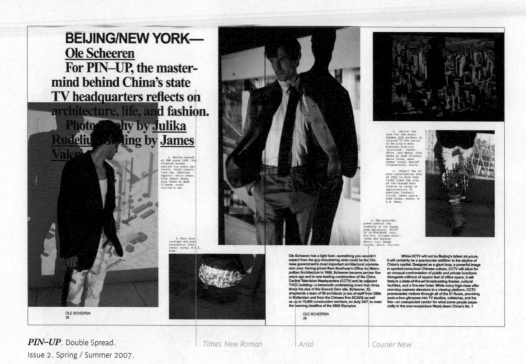

PIN–UP. Double Spread.
Issue 2. Spring / Summer 2007.

Times New Roman Arial *Courier New*

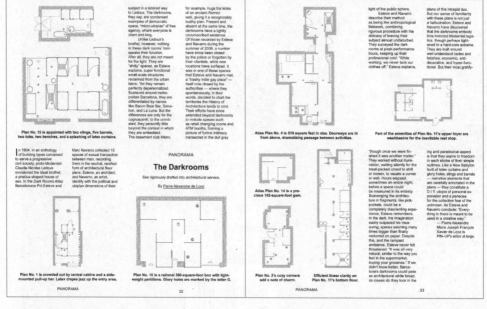

PIN–UP. Double Spread. Issue 5. Fall / Winter 2008-2009.

The typefaces in use are *Arial*, designed by Robin Nicholas and Patricia Saunders; *Times New Roman*, designed by Victor Lardent and *Courier New*, designed by Howard Ketler and Adrian Frutiger. The magazine pays a lot of attention to detail and all the while being very humble in its means, i.e. using some of the most basic standard fonts and the use of recycled paper (the Belgian Cyclus).

PIN–UP. Double Spread. Issue 6. Spring / Summer 2009.

Without leaving aside the references and sexual connotations that *pin-up* has, *PIN-UP* appears as an architectural entertainment magazine. In these terms a "Pin-up" is a review or critique of informal work which may include sketches or interim drawings, study models or sources of inspiration based on abstract references (take a simple crumpled handkerchief or a bag full of seashells as an example). The point is that this critique or review serves to clarify the initial idea and set the basic spirit of the project. Thus, the *PIN-UP* magazine is no more than that: an informal family project, a set of amusing ideas, stories and conversations and, of course, a combination of images whose main objective is not so much to focus on the technical aspects of design as the ability to capture the "architectural spirit."

Thus the various aspects involved in the development of this project are equally important, forming an equilateral triangle between typography, layout and image. Why? Simply because the readers enjoy the possibility of all sides of that triangle. There are those who purchase the magazine mainly for the design, and others are fervent readers of each and every article, essay and quotation.

The last group of readers use the photographic stories in *PIN-UP* as a source of inspiration, being less interested in the stories or the design. Of course, then there is what we could call the "ideal reader," who gives equal value to all the contents of the magazine.

Dylan Fracareta, the designer and artistic director, is responsible for the graphic design of the magazine and its visual identity in general. Then there is a sharing, where content is examined and decisions are taken about pending aspects, about the direction that a specific issue should take, etc. This means paying special attention to design details, evolving and changing with each issue but, at the same time, using very simple methods to achieve it, like using the most basic standard fonts, *Arial* or **Times New Roman** or **Courier New**, or the use of recycled Belgian Cyclus paper.

Their covers flee from what they see as conventional cover, that is, just one image. Going back to the idea that *PIN-UP* is not a hyper style presentation but an informal review which presents an impressive eclectic collection of people and ideas, the cover is the window to look into.

PANORAMA—
Expo '70 Osaka
An avant-garde flashback
to Kenzo Tange's architectural
Valley of the Dolls.

1. Aerial view of the Electrical Industries pavilion. ©1970 Japan Architect

2. Aerial view of the Québec pavilion, Sanyo pavilion, U.S. pavilion, and Australian pavilion. ©1970 Japan Architect

3. Two expo hostesses in uniform. ©Michio Yamaguchi

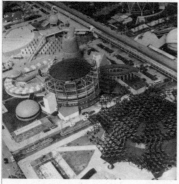

4. The Toshiba pavilion and Mitsui pavilions. ©1970 Japan Architect

5. Aerial view of the Expoland amusement park. ©1970 Japan Architect

PANORAMA
10

PIN–UP. Double Spread. Issue 2. Spring / Summer 2007.

If there is such a thing as prima donna architecture, Expo '70 certainly fits the bill like a glacé glove: On a site planned by postwar master Kenzo Tange, the 1970 World Exposition in Osaka, Japan, was a category one debutante ball.

Tange's ideas, which left total freedom to the pavilions' designers, turned a dour stretch of edge-city bush into a pulsating expo site, nestled in Japan's Kinki region. With Broadway show tunes and muzak filling the air, the flowers of the ball—and Tange did call them

flowers—were the pavilions: lightweight structural lattices; concrete fanfare; reflective glass; floating, pressurized, and tensioned plastics. There were nearly 100 of them, decked out in candy colors, accessorized with fog machines, strobe lights, and lasers, and escorted by designer robots. Many of these design concepts can be traced forward to recent work, like Diller Scofidio + Renfro's Blur Building (designed to spit water over a lake like Noguchi's gorgeous waterworks), Zaha Hadid's Landesgartenschau

(which zips from the ground like the supremely elegant Italian pavilion by Valle e Valle), Rem Koolhaas's Casa da Musica (like a moon landing sans space suit at the Japan Livelihood Industries pavilion). Detractors of the expo design committee called their laissez-fair approach a lack of control, but overall Tange was showered with accolades for the hovering space frame at the heart of the grounds—a model for the future of public space. It was a monumental techno-arena for the people, with plug-in living

capsules and other displays suspended above a vast open stage. About the master plan, Tange once said, "I don't believe people's movements can be totally controlled; I think human flows circulate freely according to laws of gravitation and on a sort of hormonal system."

The Fuji Corporation surely got the drift, hosting visitors in an overblown vaginal hull designed by a onetime understudy of Le Corbusier. It was a bundle of 16 air-beams of taut PVC, inside which celebrity

6. Italian pavilion by Valle e Valle. ©1970 Japan Architect

7. The Expo Tower by Kikutake. ©1970 Japan Architect

9. The Hitachi pavilion and Midori-Kan pavilion. ©1970 Japan Architect

8. The Sumimoto Fairytale pavilion. ©1970 Japan Architect

10. Telecommunications pavilion. ©1970 Kenchiku Bunka

PANORAMA
11

*'A huge piece of cow fat slowly melting
and pouring into a white bucket'*

Sang Bleu

Editor / Director: **Maxime Büchi**
City / Country: **London / United Kingdom; Paris / France; Laussane / Switzerland**
Founded in: **2005**
Art Direction / Graphic Design: **Maxime Büchi**
Dimensions: **240 x 330 mm**
Number of pages: **300-600**
Languages: **English** (principal) **/ French**
Periodicity: **Biannual**
Website: **www.sangbleu.com**

SANG BLEU

→ PAGE 7

→ PAGE 273

ISSN 1752-1955

SANG BLEU ISSUE III/IV. 2009. EU 44 €. UK 33 £. CHF 66

IDENTITY

CUSTOM TYPE

HEADLINE DESIGN

DESIGNER

TypoMag / *Sang Bleu*

Sang Bleu was created in London in 2004, in an attempt to create a publication that would be a proposal for a contemporary and experimental vision of modern style and culture.

Sang Bleu defends the ability to unite everything that is naturally separated. With the suggestive name of blue blood, that which is from noble descent, the magazine very skilfully gives an air of nobility to things we normally perceive as vile. But blue blood also reminds us of ink and blood mixed in tattoos. Perhaps that is why, the director and editor, Maxime Büchi dares to say that if *Sang Bleu* were not a magazine, it would be a metaphor like "a huge piece of cow fat slowly melting and pouring into a white bucket."

With this background philosophy, we find classic typefaces and of "noble descent," but updated by restless designers. Typefaces are custom made by B&P (Maxime Büchi and Ian Parry) like ***Romain BP***, ***Sang Bleu BP***, ***Sang Bleu BP Sans*** and ***New Fournier B.*** These typefaces are destined to fit in with a meticulous decadence that we find in the images which appear in *Sang Bleu*. Their commitment to the typeface is very important because they are type designers and that is why they dedicate a whole page of the magazine to talking about the types used in their publication.

With a rejection of typical categorisation and segmentation, *Sang Bleu* reaffirms its attempt to use art, fashion, sociology and literature, but also those subcultures like tattooing, body worship and fetishism to create an image carefully composed by modern urban societies or by individuals. Whatever the origins, *Sang Bleu* will treat them with a poetic mentality and great sensitivity to beauty and take them to new territories.

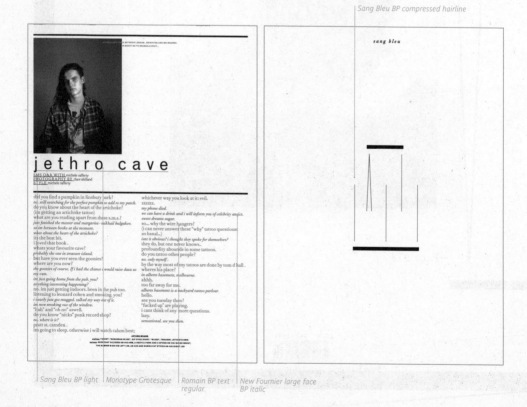

Sang Bleu BP compressed hairline

Sang Bleu BP light | *Monotype Grotesque* | *Romain BP text regular* | *New Fournier large face BP italic*

Sang Bleu. Double Spreads. Number III / IV. 2008-2009.

Sang Bleu BP hairline sang

JEANNE-SALOMÉ ROCHAT

Everything about JSR is choregraphy. From the piles of dishes standing still like Damocles Swords to the graceful run to the corner shop. And the ECAL-graduated artist intends to keep things this way, admiring obscure tribal practices waltzing with dead swiss painters, breastless saints juggling with crushed bauble debris. Jeanne-Salomé is Sang Bleu's living brain and heart-storm.

LOTTA VOLKOVA ADAM

Vladiivostok-born, Central Saint Martins-graduated Lotta Volkova Adam is on a gesamtkunstwerk. Mrs Volkova Adam draws inspiration from people and concepts that challenge the ordinary ways of thinking and behaving, ever exploring subcultures and clans, ideologies and lifestyles, applying the same brutal elegance to her contributions as to her clothing lines (Lotta Volkova, avalable from SS 2009 exclusively at MARIA LUISA). From the swamps of Cheshire Street to le Marais, Lotta is Sang Bleu fairy godmother.

ALBAN ADAM

Alban Adam is not only a severe case of hyper-activity, from Charles Anastase to Lotta Skeletrix, from Berlin's own Projekt Galerie to Sang Bleu, he is the Grey Eminence whose visionnaire brain helped founding avant-garde realms and conquer new artistic worlds. Back in Paris after living successively in London and Berlin, he currently works at Public Image PR while actively acting as Sang Bleu's neo-cortex.

Sang Bleu. Detail in actual size. Number III / IV. 2008-2009.

jethr

SMS Q&A WITH michele rafferty
PHOTOGRAPHY BY clare shilland
STYLE michele rafferty

did you find a pumpkin in fins
no. still searching for the perfect pu
do you know about the heart o
(im getting an artichoke tattoo
what are you reading apart fro
just finished the master and marga
so im between books at the moment
what about the heart of the articho
its the best bit.
i loved that book .

Sang Bleu. Detail in actual size. Number III / IV. 2008-2009.

VIEILLE FRANCE—the typography of Sang Bleu

J.-F. Rappo

Sang Bleu is a typographical project, reader. In each issue: images and fonts. Who is interested in typography? Everyone! Typography is a buzz, an urban legend, everyone knows something about it. Sang Bleu is B&P Typefoundry. B&P Typefoundry is vieille France when France, in typography as elsewhere, is modern without being aware of it anymore. Henry Poincaré, Pierre Bézier, the DS 19, Rance tidal power station, Saclay nuclear power station. Think about French synchrony in the Fifties: Adrian Frutiger's typographical diagram, Claude Lévi-Strauss' structuralism, Darmstadt School's serialism.

 Closeness and benevolence allowed Sang Bleu to remember several forgotten chapters of French modernism: the most exclusive French historical font, Romain du Roi, was copyleft and all you had to do was having an accurate look at it. A three-hundred-year field of graphical modernity was there, within the reach of your pencil, and you only needed to read Jeanne Veyrin-Forrer's amazing journey, *La lettre et le texte*. An essential book about typography—which saves oneself of referring to many blogs—, published in 1987 by the Ecole Normale Supérieure de Jeunes Filles. In a Nouvelle Vague style, the author appears taking a plein-airist pose on the back of the cover.

 BP incorporated in his schedule for several years now an evolving section devoted to French typography. Thus, for the headings of this issue, the foundry pushed to the limit two of the key milestones of French modernism. First of all, BP offers an extension of Frutiger's diagram,t planned but not realised back then: an ultra-condensed extra-thin lineal form. Then, an extra-thin linear version of Romain (which is the interpretation by BP of the 18th century Romain du Roi): a sort of epigraphical skeleton stressing the basic structure of the font, which potentially leads to a new lineal. A cluttered, enclosed, completed field? Not at all, this design could fit among the British sans-serifs or the American "gothics" and would stand out of humanist sans-serifs and grotesques. BP knows it: typography has its own agenda, a conservative delusion, in a manner of speaking, or an offbeat modernity, as this project underlines. **www.bpfoundry.com**

sang bleu
romain BP headline regular

sang bleu
romain BP text regular

sang bleu
new fournier large face BP italic

SANG BLEU
sang bleu BP compressed hairline

sang bleu
sang bleu BP light

sang bleu
sang bleu BP hairline serif

sang bleu
sang bleu BP hairline sang

Sang Bleu. Double Spread. Number III / IV. 2008-2009.
They have a very important commitment to typography. They are type designers and that is why they dedicate a whole page of the magazine to talking about the types used in their publication.

Sang Bleu BP light

Sang Bleu. Double Spread. Number III / IV. 2008-2009. *Monotype Grotesque*

Romain BP text regular Linotype Univers Monotype Grotesque Neutral BP

Linotype Univers, designed by Adrian Frutiger and *Neutral* by Kai Bernau are used in the highlights. Their clear lines and great legibility combine with the classic *Romain BP* for the text, which is inspired by the 18th century *Romain du Roi*.

Sang Bleu BP hairline sang

WWW.KRISVANASSCHE.COM

KRIS VAN ASSCHE

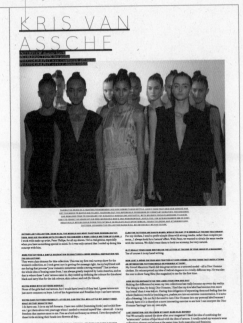

Romain BP text

Sang Bleu. Double Spread. Number III / IV. 2008-2009.

Sang Bleu BP compressed hairline

• The *Sang Bleu BP* font family is classic and of noble descent which matches the classic images.

Slanted

Editor / Director: **Lars Harmsen** and **Uli Weiß**
City / Country: **Karlsruhe / Germany**
Founded in: **2005**
Art Direction / Graphic Design: **Flo Gaertner** (AD) and **Julia Kahl** (GD)
Dimensions: **210 x 270 mm**
Number of pages: **196**
Languages: **German /English**
Periodicity: **quarterly**
Website: **www.slanted.de**

Slanted. Cover. Number 8. "2d3d.4." Summer 2009.

slanted

Slanted
Typography / Design

2d3d. 4.
Summer 2009
Issue 08

ISSN 1867-6510

Germany: € 12
Switzerland: CHF 25
UK: £16
USA: $ 26
Other Countries: € 16

From Germany, a country from which very little is mentioned about the subject of typography, comes *Slanted*, a magazine integrally based on this aspect. Something which began as a fanzine has been able to over the years bring together a broad public made up of students and professionals in the field of design. The magazine is a quarterly publication with a circulation of 10,000 copies and is available on its website, where there is an extension as a blog that has been operating since 2004 which we can see at www.slanted.de.

On this website we can find the latest updates about typography, design, illustration and photography, aspects which are immortalised in the magazine, where they can be seen in more detail. Each issue centres on a different subject, which is reflected in the design and the aspect of the magazine. The next two issues will be about Stencil and Gothic/blackletter fonts. Issue number 4, for example is dedicated to the matrix and pixel fonts; issue 5 focuses on modern ancient fonts with serif. The latest edition of *Slanted #9*, Winter 2009/10, focuses on Stencil typography, and its cutting-edge applications, so that it may serve as evidence to its unusual aesthetics which can often be undervalued.

The choice of subjects is due to their willing of presenting those fonts or typefaces that they consider of interest. Then they make the visual material the focal point for each subject as this aspect has a great influence on the look of the magazine. Although most of the content of the magazine features contributions from students and professionals, we may often find high level guests and an extensive research work. Among its public there are: professionals from the world of graphic design, students and a wide variety of readers with a common interest - typography.

We could divide *Slanted* into three separate parts. Normally, in the first part we find a variety of aspects, ranging from those fonts that have become their own brand, going on to tools for font design, illustrations of specific font names and songs of today that have been transformed into "typographic lyrics" using the appropriate fonts.

The second part of the magazine covers more general aspects, including interviews, studies, stories about typography, etc. There is a third part of the publication which is linked to the blog.

In *Slanted* we find a great interest in the present discourse about typography. This not only encompasses those who are known in the world of typography and graphic design but also includes still unknown young talents. The texts are published in the native language of the authors or designers that cooperate with them, i.e. half German, half English. On rare occasions we can find a text in French.

Their approach is marked by everything related to a typeface that is surprising, experimental, and reflective with a quality worth mentioning.

The international distribution will be a great challenge for the *Slanted* team, consisting of no more than five or six people, but they are looking forward to it. *Slanted* is in a continuous learning process with the publication of each issue, especially with regards to editorial design. They believe that each number is a little better than the previous, thus having more success than the one before. "We are very proud of our latest issues."

Slanted. Double Spreads. Number 8. "2d3d. 4."

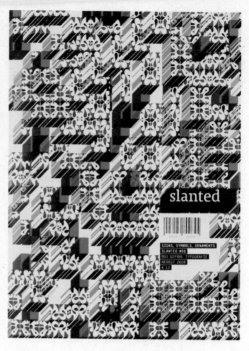

Slanted. Cover. Number 5. "Antiqua boom issue."

Slanted. Cover. Number 6. "Signs, Symbols, Ornaments."

Slanted. Backcover. Number 8. "2d3d.4."

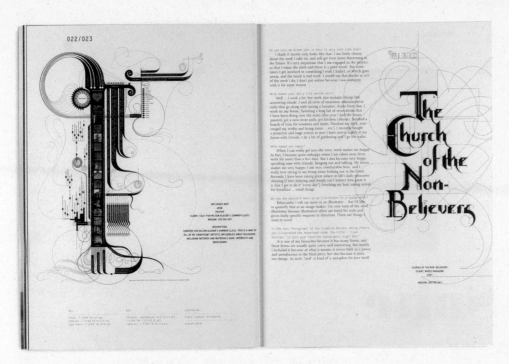

Slanted. Double Spread. Number 5. "Antiqua boom issue."

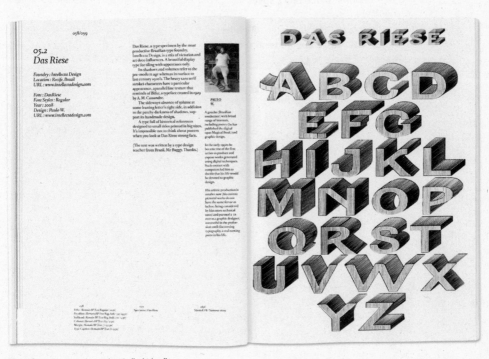

Slanted. Double Spread. Number 8. "2d3d.4."

Suite

Editor / Director: **Marta Capdevila**, **Íñigo Jerez** and **Carlos Ramírez**
City / Country: **Barcelona / Spain**
Founded in: **2006**
Art Direction / Graphic Design: **Íñigo Jerez**
Dimensions: **240 x 480 mm** and **165 x 230 mm**
Number of pages: **64**
Language: **Spanish**
Periodicity: **it is not published anymore**

Suite. Cover. Number 40.

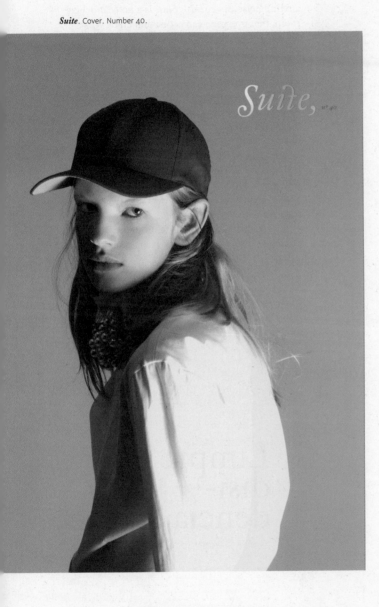

IDENTITY

CUSTOM
TYPE

LOGO

HEADLINE
DESIGN

JEREMY SCOTT

10 años

Jeremy Scott celebra sus diez años en la moda.
El diseñador americano no ha parado de dar guerra desde
1992 (Pratt University, USA), aunque el reconocimiento
internacional le llegó en 1997 con su debut en París.
Sus controvertidas colecciones son de las más arriesgadas
e innovadoras del panorama actual. Galardonado como
el mejor diseñador del año en 1996 y 1997, ocupó asimismo
el número 32 de la lista de los cien creadores más influyentes
que publicó *The Face Magazine* en 2004.
Le encontramos recuperándose del último jet-lag en
su estudio de Los Ángeles.

—*Texto de Carlos Ramírez*—
—*Fotografía de Jeremy Scott Studio*—

14

Suite. Interior page. Number 39.

Hidalgo

We receive a commercial project every month from Barcelona which reflects the illusion of an entire editorial team. Marta Capdevila, Íñigo Jérez and Carlos Ramírez give us *Suite* in the three-dimensional support form of a room where we find a changing space where music, art, literature and anything else can coexist. *Suite* is a no cost deluxe room, that everyone can access and enjoy what happens there. Its magazine concept comes from a two dimensional management which can serve as an excuse, among other things, to broadcast advertising, or to formalise contents. *Suite* is a mixture of many things, created as an independent music magazine that evolves into a trends magazine focused on all areas of creativity, with an open contemporary viewpoint. This project was created and developed in the hope of becoming a free, quality magazine. Being able to give away a well-made product was what motivated the team and its challenge to create the best publication possible with limited means.

Knowing how to modulate different aspects related to design, typography, layout and image is

Hidalgo *Hidalgo*

22 / 23 *Arte*

Limpia disi- dencia

Elmgreen & Dragset

T. de Mariano Mayer

Michael Elmgreen es danés e Ingar Dragset noruego, y desde
una dupla armada con sus propios apellidos en Berlín, tomaron
por asalto todo tipo de contextos (artístico, social, sexual...)
para modelar desde performances hasta museos. Una percepción
consciente orientada hacia la crítica y las interrogaciones en
un formato que tematiza los comportamientos contemporáneos
como un campo de operaciones. Nuevas y viejas maneras de
entender lo establecido.

Suite. Number 39. *Hidalgo* was designed by Íñigo Jerez, as all the fonts used in *Suite*.

Suite. Proof sheet of *Hidalgo* typeface.

one of the important objectives to achieve. *Suite*, as a free magazine, where contributors give their work selflessly, has great respect for all material which is edited and published; in this sense the design seeks to enhance the clarity of texts and clean images in a neutral way.

From its design, what stands out most is an extremely simple layout, where identity is based on exclusive fonts, target management and creating tension on the page in the sequence of information, a very simple and versatile recipe that evolves with total freedom.

All fonts used in Suite have been designed for the magazine in this order: *Suite Sans, Borneo, Luomo, Maeda, Interpol, Xquare, Suite Serif, Interfunktionen, Bonus, Plus, Track, Batín* and *Hidalgo*. All are designed for stylistic and functional reasons. The typeface should create the right tone for conveying written information, as the "aesthetics" help define and customise the environment in which the information is presented. At a functional level,

designing typographic fonts permits micro adjustments adapted to meet their needs, the most obvious being space saving. There are constant changes in typography, mutating or making versions or modifications on the same basis, on occasions making sharper breaks or stronger stylistic changes. In the penultimate issue, *Suite* changes format and then turns into a pocket magazine for conceptual and economic reasons. This rethinking intends to create a hybrid between magazine and book and "tics" from both worlds are mixed in the design. The main intention is to give the magazine a more sophisticated look and *Hidalgo* is created for this purpose. A Baroque inspired text font, for which a set of unorthodox ligatures are created. The intention is to create a legible sophisticated typography with a brash ligature feature. Somehow the typography maximises the design objectives, it is a basic identity element for a magazine and that is why it is worth it!

Untitled

Editor / Director: **Mike Perry**
City / Country: **Brooklyn / USA**
Founded in: **2007**
Art Direction / Graphic Design: **Mike Perry**
Dimensions: *Issue 01:* **153 x 229 mm**
 Issue 02: **229 x 305 mm**
 Issue 03: **159 x 242 mm**
 Issue 04: **165 x 248 mm**
Number of pages: **96 / 80 / 16 / 176**
Language: **English**
Periodicity: **variable**
Website: **www.untitled-a-magazine.com**

Untitled Magazine. Cover. Number 001. "A fashion Magazine".

untitled No. **001** — Featuring Alessandra Pelin, Lane Coder, Brigitte Six, Eric Ray Davidson, and More...

U. Cover. Number 002.

U. Cover. Number 003.

With this publication, Mike Perry, editor and director of *Untitled*, gives us the opportunity to explore current subjects of interest. Mike's biography is exciting and by just knowing about it, we can understand the projection of *Untitled*. Mike Perry works in Brooklyn, New York and is not only responsible for directing and editing but also for artistic direction and designing the magazine. Among his creations we can find books, magazines, newspapers, clothes, drawings, paintings, illustrations and he even teaches, when time allows it. His first book entitled *Hand Job*, published by Princeton Architectural Press, came onto the market in 2006, with rave reviews, as an excellent set of manmade typefaces that emphasise the continued need and importance of man's footprint in modern communication. The *Untitled* adventure began in 2007, as a centre where he could explore his own interests. *Untitled* is what we see, but it could be a film if someone had this idea for the next issue. In fact, the next one will be a book. The lack of precision implied by the name contains this idea of constant change, of not knowing exactly what the next issue will become. It is like a series of drawings to which the creator was not able to give a name, hence the idea of constant change, even in typefaces.

Perry creates new fonts and a variety of graphics that will inevitably change and evolve with each new job. His work has been seen by everyone including the recent show offered in London called "A Place Between Time and Space."

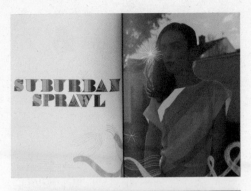
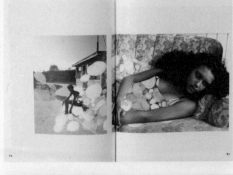
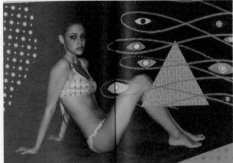
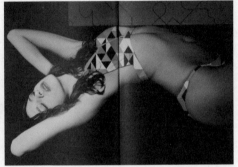

U. Double Spread. Number 002.

U. Double Spread. Number 003.

Wired UK

Editor / Director: **David Rowan**
City / Country: **London / United Kingdom**
Founded in: **2009**
Art Direction / Associate Art Director / Photography Editor:
Andrew Diprose (AD), **Gary Cadogan** (AAD), **Steve Peck** (PE)
Dimensions: **203 x 276 mm** (American A4)
Number of pages: **various, aprox. 120-150**
Language: **English**
Periodicity: **Monthly**
Website: **www.wired.co.uk**

Wired. Cover. September 2009.

IDEAS / TECHNOLOGY / CULTURE / BUSINESS

WIRED

THE FUTURE AS
IT HAPPENS

NEW
UK
EDITION

Is Branson
as green
as he
claims?
P 42

Your
future in
five (smart)
steps
P 68

THE
SEARCH
FOR DARK
MATTER

Freeze
your brain:
cryonics on
a budget
P 94

WHY 85%
OF THE
UNIVERSE
MAY NOT
EVEN EXIST

WE TEST: SLIM LAPTOPS / THE ULTIMATE CHAIR / MOWERS vs SHEEP

A cover that represents a piece about "Dark Matter" a substance that may or may not exist, that may or may not ever be discovered! They wanted to evoke a feeling of intrigue and give a feeling of its immense scale, almost sci-fi.

Wired UK. Double Spread. August 2009. This opening spread - a piece about growing fake meat - arrests the readers' attention and simultaneously set up the premise of the story: that cows will soon be replaced by test-tubes.

Wired UK, founded in London in 2009, has an in-house art department of two designers and a picture editor who draw on a large pool of freelance illustrators, photographers and typographers. Within the magazine, there is no division between art and editorial departments – everyone is able to contribute to decisions about the content and look of the magazine and any member of staff is able to propose a new story or topic.

The magazine focuses on the future, casting light on innovative people and ideas in the fields of science, technology, business, culture and design. Pages often have to communicate a large amount of information, which provides a very specific challenge. Design is frequently used to lighten what could otherwise be a daunting concept, making it accessible to all levels of readers.

Many of the magazine's layouts are deliberately playful, with extra elements placed in unexpected parts of the layout, such as the gutter or along the bottom of a page. Although the magazine's subject matter is essentially serious, the design has its own sense of humour.

In recent issues, illustrated carnivorous robots ran riot over a page, eating the page numbers, and a sheep started grazing on the background grid.

Wired seldom has celebrity covers and this presents its own constraints. "We do and will feature people on the cover," it says, "but much of what we do is based on fresh thinking and ideas, not personalities." As a result, covers often have to convey complex, abstract ideas without resorting to cliché and this has led to some innovative use of graphics, special colours and extra layers such as varnishes and foils.

Production values are kept very high throughout the magazine, ensuring that photography and artwork is shown off at its best.

Wired in the US has, from the start, created a distinctive identity and, with its powerful use of photography, illustration and type, has continually helped advance magazine design. Scott Dadich and his team have developed an instantly recognisable look and feel for the magazine and *Wired UK* is, it says, "more than happy to follow in that tradition". The magazine is very much part of the Wired family

46 EXPERTS... 99 PREDICTIONS... 14,610 DAYS...
NEWS FROM THE NEXT 40 YEARS. BY CHARLIE BURTON

Wired UK. Double Spread. May 2009. This is the opener of Wired UK's first ever cover story - setting out the values we stand for. The typography in the illustration by ilovedust, emerges out of a tapestry of images and ideas drawn from the piece, telegraphing how the magazine will stand to condense and clarify a potentially confusing future.

and it needs to look the part. At the same time, the UK edition has created a specific identity of its own: two new fonts were commissioned for the magazine's launch and much of the visual work comes from UK-based photographers and illustrators.

TURN YOUR + 05.09
HOME
INTO A GYM
EAT FOR FREE / TAKE A PRO PHOTO / PITCH ON DRAGONS' DEN / NEED LESS SLEEP / MAKE YOUR OWN MAKE-UP
By Kevin Braddock and Jack Dyson

Wired UK. Single Spread. May 2009. For the opener of a regular section "How To", the designers commissioned it to the fantastic paper illustrator Yulia Brodskaya. It's an illustration that represented the interface between the digital and analogue worlds. The design team enjoys supporting new talent, whether it's with illustration, photography or typography. Featuring a 'guest' typeface and highlighting the work of new designers is important to them and adds a little twist to the issue.

'A sexy monster haunting you for intellectual harassement!'

Chicago, Times, Plotter, Helvetica, DIN, Techno, Löhfelm, RR_02, Univers, Tiffany, Circuit, Memphis, Gringo, Zeus, The Mix, Princess Lulu, Pigiarniq, Paper, Libertine

Editor / Director: **Christian Egger**, **Manuel Gorkiewicz**, **Christian Mayer**, **Yves Mettler**, **Magda Tothova**, **Ruth Weismann**, **Alexander Wolff**
City / Country: **Wien / Austria, Berlin / Germany**
Founded in: **2002**
Art Direction / Graphic Design: **Christian Egger**, **Manuel Gorkiewicz**, **Christian Mayer**, **Yves Mettler**, **Magda Tothova**, **Ruth Weismann**, **Alexander Wolff**
Dimensions: **205 x 287 mm**
Number of pages: **36-98**
Languages: **German**, **English**, occasionally **French**
Website: **www.theselection.net/zeitschrift**

Pigiarniq

Ausgabe 17, Mai 2009, 4 Euro

CLASSIC

IDENTITY

LOGO

DESIGNER

TypoMag / *Zeitschrift: Chicago, ..., Libertine*

Times — DIN — Single pages (different issues).

Few magazines have such limited accessibility as this one: the title changes with every issue, it is usually printed in an edition of 300, and only a few art institutions in Austria, Germany and Switzerland have some of their issues available.

We are looking at a fanzine directed by artists who began in 2002 with an issue that they called *Chicago,* using the name of the typeface used in that issue as the name of the magazine. In October 2009, they published issue number 18, called *Paper,* which they distributed throughout Europe, with the font directly available on a CD in the magazine. Quite an achievement! The last title has been *Libertine.*

It's rather amusing to define their magazine as "a sexy looking monster that haunts you intellectually." Aesthetics and content come together to give us a publication that is both interesting and attractive.

The artist members of the team who prepare this publication publish the magazine about their personal encounters and their personal interests. Each issue presents about fifteen collaborations, both in text and image. Artists, writers, scientists and specialists in all fields are invited to collaborate, write, participate, entertain, play and have fun with them. Their artistic approach and boldness is what stands out.

All the fonts that have visited the magazine have left their mark in the titles, with typefaces and such attractive titles as *Chicago, Times, Plotter, Helvetica, DIN, Techno, Löhfelm, RR_02, Univers, Tiffany, Circuit, Memphis, Gringo, Zeus, The Mix, Princess Lulu, Pigiarniq, Paper* and *Libertine.*

Their typefaces have been created by typographers who are united by strong friendship ties; others were chosen because of the name or their aspect, although some may have been difficult to read on occasions. The credibility of custom fonts can hardly be found in other typefaces. The most important thing is to offer an attractive product to the reader, and above all, not to underestimate it: if their public does not find the magazine that it wants in the kiosks, they are capable of creating their own. But for now that is not necessary because the magazine is there.

All the fonts which have been used along the different numbers have made their mark in the magazine.

FRIDAY I'M IN LOVE (The Cure) / BY FRIDAY LIFE HAS KILLED ME (Morissey) / WENN JEN SCHREIBT, KANN ES SCHON DUNKEL WERDEN. WENN JEMAND SPRICHT, WIRD ES HELL. (Eva Meyer- Die Autobiographie der Schrift, Stroemfeld / Roter Stern) / LIGHTENING BOLT 07.09.04 B72 / LE TIGRE 07.09.04 FLUC MENSA

Lagerfeld entwirft für H&M, Stella McCartney für Adidas, Missy Elliott auch... so beginnen meist meine Kolumnen, somit auch diesmal, der Unterschied: Alle Buchstaben, Satzzeichen etc. stammen aus der Feder der deutschen Grafikdesignerin Undine Löhfelm, der an dieser Stelle alles Lob, größter Dank und Respekt für ihre intensive Beteiligung an dieser Ausgabe gebührt.
Ein Klassiker der Typografie „Stop Stealing Sheep - (Das Geheimnis guter Typografie)" von Erik Spiekermann ist nun auf deutsch erhältlich und unentbehrlich für alle, die mit der Materie in Berührung kommen, und das passiert oft und auch gerade jetzt... „Auf allen Seiten von Medien umgeben, das heißt, von technisch überfragenen Bildern, wurde die ästhetische Option des Mediums für veraltet erklärt, unehrenhaft entlassen, war ausgebrannt, am Ende. Die Malerei ist eine Facette, an die wir uns kaum mehr erinnern, die Skulptur ist so weit in die Vergangenheit gerückt, daß es bedeutungslos ist, ob wir Stahl schweißen oder Bronze gießen, und die Grafik sollte man offensichtlich am besten den Computern überlassen." Diese unversöhnliche, postmediale Prognose stammt von Rosalind Krauss und ist als Zitat nachzulesen in dem bemerkenswert inspirierenden Band über installative Kunst „Ästhetik der Installation" von Juliane Rebentisch / Edition Suhrkamp.
Endlich in der von den Herausgebern Thomas Feuerstein und Stefan Bidner angestrebten, massiven Buchform mit CD-Beilage vorliegend: „Sample Minds- Materialien – Materialien zur Samplingkultur" und unter den zahlreichen Beiträgen von Vera Tollmann, Diedrich Diederichsen, Heinz von Förster u.v.m. bezüglich Thema, einhergegangener Ausstellungs- und Vorstellungsreihe, ist die überfällige Cultural Studies Aufarbeitung des interalpinen Phänomens der COSMIC- Musik ein hervorzustreichender Verdienst dieses Druckwerks.
Lakonisch irritierende Antworten auf Fragen wie: „Do you like fucking fat women?" „Do you feel european?", „Do you like thinking?" eines im Sitzen pinkelnden und im Wald sinnierenden Van Goghs als proto- guerilla-girl namens Lady Chutney aka Katrin Daschner in „Killing the systems softly" (Edition Fotohof). Die Faust: geballt! Der rosa Nasendildo: selbstgehäkelt! Die Jungs: minderbemittelt! Und immer stil-und siegessicher im „flexiblen Raum aller Aspekte der nicht- (anti-, konter-) heterosexuellen Produktion und Rezeption." (Alexander Doty)... Oh boy, it's a GRRRL and who the fuck is Lulic? Groove Coverage, Meinecke... empfohlen hierzu aber: Beatriz Preciado:„Kontrasexuelles Manifest", b_books 2003, oder die neue Le Tigre „The Island" (UNIVERSAL). „Mehr pop, weniger distortion" auf Philip Quehenbergers „put me away" (Cheap), ausgewählte Kollaborationen von Positionen mit Renommé aus Kunst und Musik auf dem Berliner Label ~~Entef, Mathieu Marvin / Jazzkammer, Ava Derquer, Stunden 10 Ally, Kerstl gaets / aaron Law, Heinrik Olese, Stille und sonic 10 etc., Bomin-itte / Brally~~. Anderes Label (?) und verheißungsvoll düster die Vorschau auf ein Stück Vinyl von Electrophilia (Jutta Koether / Steven Parrino). „Never breathe what you can't see" ist kein Bonmot des nunmehr seligen Kaiser Karl des ersten, sondern der Titel der wahrscheinlich spektakulären Zusammenarbeit von Jello Biafra und der göttlichen Melvins, die wenngleich schon nicht den US-Präsidentwahlausgang beeinflußt, so doch garantiert treffend untermalt. Nicht das Buch zum Film oder umgekehrt, aber aufgrund der jeweiligen Thematik dennoch in einem Schriftzug nahegelegt: Mike Davis „Die Geburt der Dritten Welt", Assoziation A Verlag, und „Darwin's Nightmare", ein Dokumentarfilm von Hupert Sauper.
Lohnende Ausstellungsbesuche sind ab sofort in der privaten Off-Galerie ROSIEK/STAHL in der Frankfurter Moselstr. 8 möglich, erste konkrete Künstlerinnen wie Heide Heinrichs, Katrin Colt, Almut Middel oder Daniela Trixl, und ein künstlerische Bogen von abstrakt über installativ zu Video versprechen Erfolg und Publikum.
Vermutlich vergaß ich das Eine oder Andere, doch diesmal hab ich es ja nicht geschrieben...

Double Spread from *Löhfelm* issue, which is entirely written by hand.

Annex

Magazines

Tags

 BY HAND

Laser Magazine p.72, Little White Lies p.84, Love p.88, Mark p.94, Paper Planes p.139, Untitled Magazine p.171

 CLASSIC

ar p.10, Carl's Cars p.22, d[x]i p.28, Few p.46, ink p.60, Kasino A4 p.66, Laser Magazine p.72, Love p.88, Monocle p.100, Neo2 p.106, The New York Times Magazine p.112, Newwork Magazine p.120, OASE p.132, Nico p.128, PIN-UP p.146, Zeitschrift: Chicago, ..., Paper p.178

 IDENTITY

Back Cover p.16, Few p. 46, Monocle p.100, Nico p.128, OASE p.132, Sang Bleu p.152, Suite p.166, Zeitschrift: Chicago, ..., Paper p.178

 CUSTOM TYPE

Back Cover p.16, d[x]i p. 28, Elephant p.32, Emigre p.38, Few p.46, Lieschen p.78, Neo2 p.106, The New York Times Magazine p.112, Newwork Magazine p.120, Paper Planes p.138, Sang Bleu p.152, Sang Bleu p.152, Slanted p.161, Suite p.166, Wired UK p.174

 LOGO

ar p.10, Emigre p.38, Laser Magazine p.72, Love p.88, Neo2 p.106, Newwork Magazine p.120, OASE p.132, Paper Planes p.139, Slanted p.161, Suite p.166, Untitled Magazine p.171, Wired UK p.174, Zeitschrift: Chicago, ..., Paper p.178

 HEADLINE DESIGN

Carl's Cars p.22, d[x]i p.28, Elephant p.32, Emigre p.38, Futu p.52, ink p.60, Kasino A4 p.66, Lieschen p.78, Little White Lies p.84, Love p.88, Mark p.94, Neo2 p.106, The New York Times Magazine p.112, Newwork Magazine p.120, OASE p.132, Paper Planes p.138, PIN-UP p.146, Sang Bleu p.152, Slanted p.161, Suite p.166, Suite p.166, Untitled Magazine p.171, Wired UK p.174

 DESIGNER

Back Cover pág.16, d[x]i p.28, Elephant p.32, Emigre p.38, Futu p.52, ink p.60, Kasino A4 p.66, Laser Magazine p.72, Lieschen p.78, Newwork Magazine p.120, Nico p.128, OASE p.132, Sang Bleu p.152, Slanted p.161, Untitled Magazine p.171, Zeitschrift: Chicago, ..., Paper p.178

Blogs and webs

Colophon

2 011 Magazines. 5 166 Covers. 2 474 People. 662 Publishers. *Colophon* is an on-going project building a database of magazines and a network of organizations and people from all over the world.
Looking for an independent magazine? You will find it here.
blog.colophon2011.com

Designing Magazines

Designing Magazines is blog edited by Jandos Rothstein. The blog has debate and alternative points of view.
www.designingmagazines.com

Digital Magazines

Everything you need to know about the next revolution in publishing. Digital magazines, emagazines, e-readers, Amazon Kindle, iPhones and more.
www.digitalmags.blogspot.com

Linefeed.presspublish

In September 2006, Michael Bojkowski set up the blog called Boicozine in order to document design and pop culture phenomenon and to plug some gaps in the online mind set. Boicozine has had a redesign in 2009 along with a name change and is now known as Linefeed. Linefeed seeks to round up the various social editorial work they produce.
www.linefeed.presspublish.info

magCulture

magCulture written by Jeremy Leslie celebrates magazine and (occasionally) newspaper design. All types of magazine are covered – independent and mainstream – the sole criteria being the innovation and creativity of the magazine.
magculture.com/blog

Mark Porter

Random thoughts, experiences and observations about design, media and other things.
www.markporter.com/notebook

Mag scene

Magpie likes observing these sleek birds with a tapering tail. And like Magpies, she lives with the burden of being a "chatterer", even though she believes that she is rather shy, reserved and unobtrusive :)
www.mag-scene.blogspot.com

Magtastic

It is written by Andrew Losowsky. This website focuses on developments in the magazine industry around the world.
www.losowsky.com/magtastic

mag.nificent.com

I'm the chick at the check-out with the stack of 10 magazines the 1st of every month. The girl with her collection painstakingly aligned, alphabetized and organized chronologically and according to size, and I know there are others out there like me. Denizens of culture, art, fashion and the obscure you will find here.
mag.nificent.com

Magnation

Mag nation is the brain child of Ravi, Suchi and Sahil. They started in Auckland, New Zealand with a store called Mega Mags on Queen St. The devotion to slightly off the beat mags convinced them that there were enough silly magazine lovers like them to enable them to expand the magazine superstore concept. So they polished up their begging bowls and did a lot of busking.
www.magnation.com

Symposiums

NMCA

The Nation Magazine Cover Archive (NMCA) is a non-commercial 'hobbysite' and online archive devoted to helping keep inspirational magazine design alive. These are strange days for editorial designers with homogenisation and closure of many well known (and loved) titles and independent publishers emerging to fill the gaps.

nmca.presspublish.info

Printfetish

News, information, reviews and history on the subjects of beautiful magazines, self-published 'zines, handmade books, small press, comix, and art books and miscellaneous printed ephemera.

www.printfetish.com

Stackmagazines

Stack is a unique service that brings together the best independent English language magazines from around the world and delivers them direct to your home. Beautifully made and offering an intelligent, alternative view of films, music, culture, current affairs and whatever else crosses their pages, they guarantee to bring a fresh perspective on the world.

www.stackmagazines.com

SPD

The Society of Publication Designers is dedicated to promoting and encouraging excellence in editorial design.
The members are art directors, designers, photo editors, editors and graphics professionals.
Since drafting its charter in 1965, the SPD remains the only organization specifically addressing the visual concerns of print and online editorial professionals.

www.spd.org

Colophon

Colophon organizes a biennial symposium for magazine makers, experts, advertisers, readers and all creatives involved in the world of the independent magazine. This international event celebrates excellence and innovation, and promotes exchanges between key players within independent magazine industry.

blog.colophon2011.com

Magazines about typography

Back Cover // www.editions-b42.com

This publication focuses on the analysis and discussion of graphic design, the different typefaces and visual art. (See pages 16-22).

Baseline // www.baselinemagazine.com

Baseline is intended to reflect all aspects of typeface, including design, history, uses and its relationship to the graphic world of arts and crafts. The magazine contents are deliberately eclectic. It publishes both previous material and new material from academic and journalistic sources. Their work is held in high esteem because of their use of materials and production values.

Eye magazine // www.eyemagazine.com

Eye, International Report on Graphic Design is a quarterly magazine for all those people related to graphic design and visual culture. It was first published in London in 1990.

Eye was founded by Rick Poynor, a prolific writer about graphic design and visual communication. Poynor edited the first 24 numbers (1990-1997). Max Bruinsma was the second editor, editing issues 25-32 (1997-1999), before the current editor John L. Waters who relieved him in 1999. Stephen Coales was the artistic director for issues 1-26, Nick Bell for issues 27-57 and Simon Esterson has been the artistic director since issue number 58.

Some of those who have habitually worked with them are Phil Baines, Steve Hare, Richard Hollis, Robin Kinross, Jan Middendorp, J. Abbott Miller, John O'Reilly, Rick Poynor, Alice Twemlow, Kerry William Purcell, Steve Rigley, Adrian Shaughnessy, David Thompson, Christopher Wilson and many more.

idea Magazine // www.idea-mag.com

Japanese graphic design and typeface magazine.

ink // www.ink-magazine.com

A French magazine founded in 2006 and designed by Patrick Lallemand and Pierre Delmas Bouly from the Superscript Studio in Lyon (http://www.super-script.com). Its creators define it as "a participatory magazine about graphic design and typography." (See pages 60-64).

Slanted // www.slanted.de

The design and typography magazine *Slanted* is a magazine that is exclusively about typeface - something which is not given a lot of attention in Germany. The magazine has a supplementary blog that can be found at www.slanted.de which has been working since 2004, and offers daily typeface, design, illustration and photography updates, while at the same time, the magazine goes deeper into these issues and is responsible for immortalising them. Each issue focuses on a different theme. (See pages 160-164).

TypoGraphic, the ISTD journal // www.istd.org.uk

The specialised *ISTD journal* provides a forum for discussion and constructive criticism about typography and graphic communication; each issue includes subject discussions conducted by recognised designers and educators. Published since 1971, under several editors, it has recorded the three most dynamic decades in the development and evolution of typeface. The ISTD specialised journal is sent to all its members free of charge.

Typografische Monatsblätter // www.tm-rsi-stm.com

This Swiss typography, writing and visual communication magazine, founded in 1933, is an international reference because of its excellent use of images, typography and the editorial with a modern interpretation of issues, and a persuasive focus of high quality.

Typography Papers // www.hyphenpress.co.uk/subjects/Typography_papers

Collection of everything good that has been published by the University of Reading Typography Department.

TYPO // www.typo.cz

TYPO is a magazine published in Prague, dedicated to typography, graphic design and visual communication. The magazine works with authors and theorists from various countries; at present it has published articles written by Rick Poynor, Jan Middendorp, Peter Bil'ak, Kevin Larson, Albert-Jan Pool and Adam Twardoch. The articles are published in Czech and English.

Magazines about typography that have already disappeared

Emigre // www.emigre.com

Emigre defines itself as a graphic design magazine. Published in English from 1984 until 2005, and with a quarterly circulation despite its irregularity, its director and designer Rudy VanderLans has a great influence in the design and creation of the publication. His philosophy could be expressed by the idea of starting from scratch in the publication of every one of the issues. (See pages 38-45).

Typographica // en.wikipedia.org/wiki/Typographica

Typographica was the name of a magazine specialised in typeface and visual arts, founded and edited by Herbert Spencer from 1949 to 1967. Spencer was 25 years old when the first issue was published. Typographica was produced in two series: "the new" and "the old". Each of them consisted of sixteen published issues.
http://en.wikipedia.org/wiki/Typographica

tipoGráfica //www.tipografica.com

Published in Spanish, tpG was an Argentinean magazine, directed by Ruben Fontana which stopped publication in 2007. Its website is an archive that contains part of the content published since 1977.

U&Lc // www.itcfonts.com/Ulc

U&Lc (Upper & lower case) was the ITC publication (International Types Corporation) during many years. Now U&Lc Online is the specialised international ITC magazine about graphic design and digital multimedia and is part of the ITC web. It provides numerous articles and resources on typography.

Typefaces in use

Logo TypoMag:
FF Legato and custom retouching executed by Laura Meseguer,
taken from *Poster* typeface by Íñigo Jerez.
Interior:
Poster Display, Adobe Caslon and *FF Legato*.

TYPOMAG
Copyright © 2010 Index Book, S.L.
© of the texts, its authors
Laura Meseguer
Luis Mendo
Adela Peláez

Index Book S.L.
Consell de Cent 160, local 3
08015 Barcelona, Spain
Tel.: +34 934 545 547
Fax: +34 934 548 438
E-mail: ib@indexbook.com
www.indexbook.com
ISBN 978-84-92643-37-0

Art Direction: Laura Meseguer (www.laurameseguer.com)
Graphic Design: Laura Meseguer
Contents: Floor Koop, Laura Meseguer and Claudia Parra
Texts: Adela Peláez

Printed in Dami Editorial & Printing Services Co. Ltd.